THE
BEAUTY OF FAITH

THE BEAUTY OF FAITH:

USING CHRISTIAN ART TO SPREAD THE GOOD NEWS

JEM SULLIVAN, PH.D.

Our Sunday Visitor Publishing Division
Our Sunday Visitor, Inc.
Huntington, Indiana 46750

Nihil Obstat: Msgr. Michael Heintz, Ph.D., *Censor Librorum*
Imprimatur: ✠ John M. D'Arcy
Bishop of Fort Wayne-South Bend
November 11, 2009

Cover design by Tyler Ottinger / Interior design by Siok-Tin Sodbinow
Cover image: Jan Van Eyck, *Annunciation*, c. 1434/36 (detail),
National Gallery of Art, Washington, DC.
Interior art: Our Lady of Guadalupe, Basilica of the National Shrine of the Immaculate Conception / Geraldine M. Rohling.
Giovanni di Paolo, *The Annunciation and Expulsion from Paradise,* c. 1435, National Gallery of Art, Washington, DC.

As we progress in this way of life and in faith,
we shall run on the path of God's commandments,
our hearts overflowing with the
inexpressible delight of love.

— Rule of St. Benedict, Prologue

Finally, brethren, whatever is true,
whatever is honorable,
whatever is just, whatever is pure,
whatever is lovely, whatever is gracious,
if there is any excellence,
if there is anything worthy of praise,
think about these things.

— Phil 4:8

"Blessed are the pure in heart,
for they shall see God."

— Mt 5:8

This book is dedicated
to my husband, Scott,
whose artistic works strive to express
the beauty of faith.

CONTENTS

FOREWORD

Readers of *The Beauty of Faith* will find it provides a great service to the Church by positioning our understanding of sacred art within its rich historical and theological context.

From the early Church on, when symbols were used in the catacombs to identify Christians under threat of persecution, Christians have been aware of the limitations and abilities of art to convey — even, at times, secretly — the truth about Jesus Christ. Throughout the West, religious art has been described as the "Bible of the illiterate," a pedagogical tool for teaching the events of salvation history to those lacking ability to read or access to a Bible. Today, especially in the West, illiteracy is considerably less common, and access to the Bible is as easy as an Internet search; these facts alone can seem to diminish the need for sacred art.

However, even in our highly literate society, with easy access to the written word in a variety of media, we still hear it said that a picture is worth a thousand words. The reason for this is simple. As visual people, what we apprehend through our senses — what we see, what we hear, what we touch — is something that we can instantaneously know without the filter of excessive verbiage. Little wonder that in ancient Greece, the word for "to know" was the past tense of their word "to see."

For this reason, sacred art is more than a mere conveyance of facts. It is, after all, sacred art, and its

sacredness goes beyond its religious subject matter or its ecclesial place of display. Fundamentally, its sacredness implies a function beyond depiction. The creation of sacred art can be considered in some sense a holy act. For a painting's pigment or a sculpture's shape is the beginning of a dialogue where the spiritual contemplation of one person — the artist — is set forth in such a fashion as to provoke the beginning of the viewer's contemplation. Consequently, we cannot overestimate its capacity to become, as a true method of Catholic education, "a place to encounter the living God who in Jesus Christ reveals his transforming love and truth."[1]

To some degree, the rise of our image-centered culture had its origins in the rise of Renaissance art in the West with its shift away from iconography. Whereas iconography, so popular in the Eastern Rite Catholic Churches, used strongly theological symbolism to bring spiritual truths to the fore, the Renaissance marked a change of technique as well as a return to the showcasing of the human figure found more in pagan Roman and Greek art than art of the Christian tradition. However, this shift was more than a change of technique or detail. It was a change in the purpose of art, from representing a spiritual reality to representing a material reality — what we call realism, focusing on the dimensions and form of the natural world.

In the process, we may have lost some of the spiritual dimension. Of course, nearly every artistic age has temptations it expresses and indulges in through art. In our time, there is the temptation to follow in the footsteps

[1] Benedict XVI, Address to Catholic Educators, Apostolic Visit to the United States.

of spiritualism; rather like catering to the friend of Freud's who defined his surety in God as stemming from an "oceanic feeling," there can be a temptation to treat religious art as useful only for sharing of a positive spiritual feeling and to ignore its potential for truly evangelizing — for conveying and inspiring the life of the Gospel by "reawaken[ing] a longing for the Ineffable, readiness for sacrifice, and the abandonment of self."[2]

For this reason, Jem Sullivan's work is not only astute but also especially relevant today. And *The Beauty of Faith* provides us with the extraordinary idea of capturing and adapting the monastic practice of *lectio divina*, meditations on the readings of sacred Scripture, for Christian art. Visiting any museum, one can't help but notice that religious art either depicts the saints or is scripturally based. Sullivan recognizes that what connects us to this art is not so much the technique, but the interpretation, which is to say, the spiritual vision of the artist. The artist manifests his interpretation of the Scriptures, a vision, which in great art is found through profound meditation. That is, the very production of great sacred art rests upon a process of *lectio divina*.

Lest we ever doubt the theological importance of art and its ability to evangelize, let us remember that in fact it was on the American continent that God himself impressed upon St. Juan Diego's tilma an image — the image of Our Lady of Guadalupe — and thereby converted the entire new world to the "Word of God" through the "image" of his mother.

[2] Benedict XVI (Cardinal Ratzinger), Address to Communion and Liberation group at Rimini.

This gives artists a unique role as both contemplatives and as evangelists. What is needed is not a balance of spiritual and material aspirations, as if the spiritual and material worlds were polar extremes, but a harmonization of them, by which the spiritual brings the material to fulfillment. As Pius XII encouraged Italian artists:

> Seek God here below in nature and in man, but above all within yourselves. Do not vainly try to give the human without the divine, nor nature without its Creator. Harmonize instead the finite with the infinite, the temporal with the eternal, man with God, and thus you will give the truth of art and the true art.[3]

The Beauty of Faith will make a welcome addition to the bookshelves of every Catholic.

<div align="right">

— Carl A. Anderson
Supreme Knight, Knights of Columbus

</div>

[3] Pius XII, Address to Italian Artists.

CHRISTIAN ART — A VISUAL GOSPEL FOR A VISUAL CULTURE

In the opening year of his pontificate, Pope Benedict XVI presented to the Church a *Compendium of the Catechism of the Catholic Church*. Included in this catechetical *Compendium* was a new dimension — fourteen works of sacred art that visually illustrate and communicate the faith of the Church as believed, celebrated, lived, and prayed. In introducing this *Compendium*, Pope Benedict drew attention to the catechetical value of Christian art in these words:

> The centuries-old conciliar tradition teaches us that images are also a preaching of the Gospel. Artists in every age have offered the principal facts of the mystery of salvation to the contemplation and wonder of believers by presenting them in the splendor of color and in the perfection of beauty. It is an indication of how today more than ever, in a culture of images, a sacred image can express much more than what can be said in words, and be an extremely effective and dynamic way of communicating the Gospel message. . . . Sacred images proclaim the same Gospel message that the Sacred Scriptures transmit through words and they help reawaken and nourish the faith of believers.

What is the place and relevance of Christian art in today's "culture of images"? How are masterpieces of Christian art to be placed at the service of the New Evangelization, catechesis, preaching, and faith formation so as to reawaken and nourish the faith of believers? Might Christian art serve as a *visual Gospel* for *a visual culture* today?

Art in Human Experience

The National Gallery of Art in Washington, DC, is one of many impressive monumental buildings in the nation's capital. The Gallery's West Building Rotunda, with its massive marble columns and neoclassical dome modeled after the Pantheon, is an awe-inspiring introduction to the museum's masterpiece collections. The triangular wide-open spaces of the East Building offer a spacious setting, bathed in natural light, for artistic works that span the twentieth century. But the buildings, impressive as they are, serve only as gateways to another world — a world of artistic beauty.

Time and time again, I have seen the power of art to attract, inspire, and move people, even profoundly. I have witnessed the capacity of art to transform people of every age and background — young and old, attentive and distracted, learned and simple, the wide-eyed neophyte and the seasoned connoisseur.

Take this scene unfolding on a summer day in the National Gallery. It describes, in part, what you may have also experienced while encountering a favorite artistic masterpiece.

A trip to the nation's capital would be incomplete without a visit to the art collection that bears the name

"national," so steady streams of visitors from around the world enter the National Gallery's doorways each day. In the summer, the cool interiors also provide a welcome respite from the heat. Drained and exhausted from "tourist fatigue," visitors line up for one of the gallery's many scheduled tours. Even as the stifling humidity dulls their facial expressions and droops their shoulders, these determined pilgrims begin their journey through a world-class art collection that spans six centuries . . . and their transformation through beauty is about to begin.

As visitors move through gallery upon gallery of masterworks of Renaissance, Baroque, French, Spanish, German, American, and twentieth-century art, they are compelled to leave behind the dust, heat, distractions, and noise of this serious and powerful city. Turning a corner into each new gallery, they are treated to a visual feast served by some of the world's creative geniuses — Fra Angelico, Leonardo da Vinci, Titian, Rembrandt, Rubens, Monet, Turner, Van Gogh, and Picasso, to name only a few. Color, line, shape, movement, light, and darkness in various artistic forms transport ordinary people into an extraordinary world, and few leave without feeling refreshed in mind, body, and spirit. Their expressions only an hour earlier, dazed by travel and bereft of interest, now radiate something of the beauty they have gazed upon, the enthusiasm of discovery, and the spark of creativity.

Many will return another day for an encounter that transcends words. They have experienced firsthand what Plato, and numerous thinkers since, have put into words: Beauty opens to transcendence; it stirs and reawakens the spirit; art uplifts and gives wings to the soul.

Christian Art — A "Concrete Mode of Catechesis"

For several centuries, the dominant forms of art in the Western world were Christian in theme, location, provenance, and patronage. From the Emperor Constantine's conversion to Christianity in the fourth century till the religious tumult of the sixteenth and seventeenth centuries, the Church was by far the principal patron of the arts. Art expressing Christian themes, symbols, and biblical references was the dominant key of creative expression in the West. *Sacred art*, with its specifically Eucharistic context and purpose, came to be distinguished from *religious art* that more broadly expresses biblical, spiritual, and human themes.

Today, we have grown accustomed to encountering masterpieces of Christian art in museums and art galleries. However, historically, much of the heritage of Christian art was first intended not for display in museums, for the discernment of art critics or the research of art historians. Rather, Christian art was created primarily for places of liturgical worship — cathedrals, churches, chapels, and altars. These works of sacred and religious art offered the Christian at prayer a glimpse of the heavenly liturgy, of which the earthly liturgy was a preparation and participation. Created to nourish and deepen the faith of believers, Christian art was not intended to simply offer aesthetic delight or gain the approval or disapproval of art critics. Rather, within the original liturgical context, sacred and religious art served as a "concrete mode of catechesis," and a kind of "Bible of the poor."

For centuries, then, Christian art has played a significant — but now largely overlooked — role in evangelizing and catechizing generations of believers.

This role of Christian art was not limited to programmed objectives but provided an intuitive and holistic pedagogy that engaged the whole human person — mind, will, emotions, body, and senses.

In a world where Christian art no longer dominates the cultural imagination as it once did, the visual impact of this historical fact is easily lost today. For now we live in a different kind of visual culture, one in which it is possible to speak of "sensory overload" and "sensory addictions" among children, teenagers, and adults that result from the superabundance of images and visual experiences that flood everyday life. In this image-saturated culture of television, the Internet, and instant messaging, blogs, and billboards that make up the "Information Age," it is easy to forget that there was a time in the West when sensory experiences were imbued through and through with religion in general and Christianity in particular.

Christian Art As a Visual Gospel

This book reflects on a specific form of art — the Christian art of the West — and its relevance in today's image-saturated world. It does not attempt to take up vital and age-old theological and philosophical questions on the definition or nature of beauty or discuss the characteristics of genuine sacred art. Nor is it written from an art critic's or art historian's perspective. Rather, its primary aim — written from the viewpoint of a teacher, a catechist, an evangelist — is to reflect on why and how Christian art can serve today, as it did in past centuries, as a *visual Gospel*. It proposes that masterworks of Christian art are invaluable, even necessary, aids in the New Evangelization called for by Pope John Paul II and Pope Benedict XVI.

This proposal is inspired by the claim that great works of art "are all a luminous sign of God and therefore truly a manifestation, an epiphany of God" (Pope Benedict XVI, Bressanone, August 6, 2008).

In this book, we offer the reader four reasons — theological, human, historical, and cultural — for a renewed appreciation and recovery of the vital role that Christian art plays when integrated in liturgy, preaching, evangelization, catechesis, and spiritual formation. By reflecting on these four reasons, the reader is invited to consider the vast treasury of Christian art as a way to bring the "Good News" to our culture.

We will begin with a practical and pastoral adaptation of the ancient monastic practice of *lectio divina* for reflection on masterpieces of Christian art. Rooted in the Catholic theological and spiritual tradition and written as a hands-on approach — a "how-to" of sorts — this adaptation of *lectio divina* aims to assist the reader to better understand, appreciate, and spiritually appropriate masterworks of sacred and religious art.

This adaptation of *lectio divina* aims to overcome the commonly held notion that art appreciation is the reserved domain of an elite few art critics and connoisseurs who possess specialized and scholarly knowledge of art history and artistic symbolism. To the contrary, it's a long-standing fact that much of Christian art was originally created for the masses, for the "person in the pew," for ordinary believers. Over time, these faithful learned to "read" religious symbols and incorporate the theological and spiritual meanings conveyed through them into prayer, memory, and religious imagination. Christian art served to purify the senses for union with God.

This approach has been particularly inspired by the tradition of Eastern Christianity, in which icons — sacred images of Christ, Mary, the saints, and biblical narratives — have long been deeply integrated into liturgical and personal prayer, spirituality, and daily life. Icons are sacred images born of prayer and fasting and painted (or "written") according to established canons. The rich liturgical tradition of praying with icons encourages all Christians to approach genuine masterpieces of Christian art in a spiritual and prayerful way. For a reader seeking to explore the wealth of Christian art in greater depth, this book offers a concrete means to integrate sacred and religious art into ongoing and daily faith formation, evangelization, catechesis, prayer, and the spiritual life.

Finally, this book is an invitation — to parents, pastors, teachers, evangelists, catechists, spiritual formators, students, and lovers of art — to rediscover the tradition of Christian art at the service of inspiring, teaching, forming, and renewing faith. Instructors of art theory, Christian art history, and theology and the arts are invited to consider the immense heritage of Christian art not only as a source of historical insight into past religious beliefs and sociocultural norms but as bearing spiritual and cultural relevance today. Those entrusted with the formation of seminarians can use this book in considering the integration of genuine aesthetic experiences as preparation for a life of virtue, contemplation, renunciation, and service to the Church. For those who help form business leaders, it's worth a pause to reflect on the place of beauty as the visible manifestation of Goodness and Truth in management, business ethics, and leadership training.

It is this author's humble hope that the reflections presented in this book will in some small way add to and continue the lively conversation currently underway on the transforming power of beauty offered by artists as a gift to the human family in masterpieces of Christian art.

WHY BOTHER WITH CHRISTIAN ART?

Joshua Bell is a violinist known around the world for his remarkable talent and musical brilliance. A child prodigy, he began playing the violin at the age of four and is now a critically acclaimed and sought-after virtuoso. Bell performs classical masterpieces on a violin that is, itself, a handcrafted masterpiece — a rare eighteenth-century instrument called the Gibson ex Huberman, made by Antonio Stradivari in 1713. The violin is reportedly valued at some $3.5 million, and a single Bell concert typically commands close to a half million dollars. So why was this world-class virtuoso playing timeless pieces of classical music, like Bach's *Chaconne* and Schubert's *Ave Maria,* on his priceless violin one cold January morning during rush hour in a Washington, DC, train station?

Would people on their way to work notice or stop to listen to masterpieces of classical music? Would you have stopped to listen? Amidst the hectic pace of everyday life, is there room for beauty? Could beautiful music transcend the hurried moment and the ordinary location of a train station at morning rush hour? In the routine of daily living, might art serve as a "signal of transcendence," in the phrase of sociologist Peter Berger?

These were some of the questions that Joshua Bell and the *Washington Post* hoped to answer during his hour-long "experiment" (for the full story see the article

"Pearls Before Breakfast," *Washington Post*, Sunday, April 8, 2007). These are also some of the questions this introductory chapter seeks to answer with particular reference to Christian art.

From our waking moments to the time we rest at the end of each day, our senses are the gateways through which we experience the natural world and the surrounding culture of media, entertainment, and mass communication. Within this contemporary cultural context, what abiding relevance does Christian art have? Do masterpieces of Christian art — beauty in the form of words, music, and the figurative arts — serve simply as charming ornamentation, aesthetic high points, or historical reminders of past sociocultural times? Do we view Christian art as another product to be consumed? Do we approach Christian art as a form of aesthetic entertainment to be passively received? Or can Christian masterpieces of art serve deeper human, pastoral, and spiritual needs?

Is artistic beauty essential to the Church's public prayer of the Eucharist, and ongoing faith formation and evangelization of culture? And finally, how is the Church's artistic heritage to be placed at the service of "making belief believable," to quote Flannery O'Connor? Let's look at a few of these questions.

Why Bother with Art?

For centuries in the West, sacred and religious art served as a means of expressing and communicating Christian faith. Scenes from the life of Christ, the Virgin Mary, Christian saints, and biblical history were, in ages past, the inspiration of art, architecture, music, and literature.

Today, however, the sacred and religious artistic heritage of the West barely resonates in the common religious imagination as it once did. Now, the visual deposit of faith that is Christian art has only a negligible place in pastoral planning, liturgy, catechesis, and evangelization. The Church, once the principal patron of the arts, no longer serves this critical cultural role. Limited resources and stretched budgets at diocesan and parish levels make the pastoral integration of the arts a low priority.

Consequently, the faithful today are more likely to encounter Christian masterworks — paintings, sculpture, sacred music, sacred architecture — in museums or performance halls than in the local church or parish faith formation program. A believer who wishes to see a beautiful painting of the Madonna and Child, a sculpture of a beloved saint, or an altarpiece with scenes from the life of Christ or the Bible will be more likely to encounter art expressing such themes as "exhibits" rather than as integral parts of Church life.

For younger generations of Christians, the loss of familiarity and ready access to the Christian tradition of sacred and religious art is particularly real. Born and educated in the age of computers, the Internet, and advanced media and communication technologies, young people instantly recognize and readily immerse themselves in the images and sounds from popular movies, music, commercials, advertising, and video games. Unlike any previous generation, they are saturated, consciously and unconsciously, with values conveyed through the visual and sensory culture that surrounds them. Pastors, preachers, educators, and catechists are led to wonder — could the vast heritage of Christian art, from both the past

and the present, not shape and influence these generations in a similar formative way?

Sensory Dissonance — A Pastoral Challenge

In this light, a striking paradox — a sensory dissonance, if you will — marks the relationship of Christian art to contemporary culture. The *diminishing* place and role of Christian art in liturgy, catechesis, and evangelization has occurred precisely at the moment when popular culture, in content and medium, has become *increasingly* sensory and visual. Everyday life is infused with images, words, and sounds aimed at engaging mind, will, senses, and emotions; however, the daily or weekly experience of liturgy, catechesis, faith formation, and spirituality is plain, appealing primarily only to the intellect or emotions — and often, starkly bereft of beauty. While the surrounding culture appeals *more* and *more* to visual and sensory experiences, *less* and *less* value is placed on visual, sensory, and artistic expressions of faith within the Christian community.

This sensory dissonance offers a challenge not only for individual believers but for parents raising children, pastors and homilists serving the spiritual needs of the faithful, catechists and evangelists involved in sacramental preparation and ongoing faith formation, and those entrusted with vocation and seminary formation. How is the Church to "make belief believable" to the video-game, Facebook, and YouTube generations? Clearly, the sensory dissonance experienced between life in society and the life of faith touches the heart of the Church's mission to evangelize culture.

St. Thomas Aquinas teaches that "the beautiful is that quality of a work of art or object of nature which, once experienced by the senses, pleases by stirring desire, arousing a feeling of admiration, and producing love in contemplative delight."

Can the Church dispense with beauty in liturgy, catechesis, and evangelization as it seeks to engage people profoundly shaped by the dominant information and media culture? To effectively proclaim the Gospel message to generations deeply formed by a sensory culture, can the Church afford to overlook sacred and religious art as tools of the New Evangelization?

In the following chapters, a rediscovery of Christian art is encouraged as one culturally necessary tool of evangelization, faith formation, and spiritual and moral renewal. Parents, pastors, catechists, educators, and artists are invited to reflect on ways in which this sensory dissonance between the life of faith and life in society can be overcome, and their ministries strengthened, within the Church's evangelization of culture.

LECTIO DIVINA AND CHRISTIAN ART

Lectio divina is an ancient Christian practice receiving renewed attention today. Since the beginning of his pontificate, Pope Benedict XVI has spoken on several occasions of the need to recover this early Christian approach to reading Sacred Scripture. The Holy Father urges the faithful to rediscover the practice of *lectio divina* (literally understood as "divine reading," or "holy reading") with these words:

> The diligent reading of Sacred Scripture accompanied by prayer makes that intimate dialogue possible in which the person reading hears God who is speaking, and in praying, responds to him with trusting openness of heart. . . If it is effectively promoted, this practice will bring to the Church — I am convinced of it — a new spiritual springtime.[1]

What is *lectio divina*? How might this practice produce "a new spiritual springtime" in the Church? Why did a General Synod of bishops, meeting in October 2008 in Rome to discuss "The Word of God in the Life and Mission of the Church," strongly encourage a return to the riches

[1] Address to the International Congress commemorating the 40th anniversary of *Dei Verbum,* September 16, 2005. www. vatican.va. / holy_father/benedict_xvi/speeches/2005/september/documents/hf_ben-xvi_spe_20050916_40-dei-verbum_en.html (© 2005 Libreria Editrice Vaticana).

of *lectio divina*? And why does a book on Christian art seek to adapt *lectio divina*?

Lectio Divina — An Alternative to What?

Think of the last time you read something of interest on a printed page. Perhaps it was the morning's newspaper, a journal or magazine article, a new best-seller or a classic book, an online article or blog spot, your e-mail, an academic journal or scholarly volume. Chances are you were reading at a good, even rapid, pace to cover as much ground as possible. You were reading for information, knowledge, and comprehension.

Today, this is the way we typically read the printed words that surround our daily lives. We read as efficient consumers of news and information updated in "real time," as hurried bystanders along the highways of expert commentary and scholarly learning, as frazzled passengers caught in the rush hour of high-speed traffic that is human communication today.

A visual counterpart to modern "speed reading" is fast-paced seeing and hearing. It is said that a thirty-second television commercial can contain several hundred images aimed at viewers at a pace so rapid that it defies full awareness. Are we consciously mindful of all that we "see" in the multiple and fragmented images that flicker on screens before us on television, the Internet, in movies, or via other mass media?

This hurried — at times, frantic — pace of reading, hearing, and seeing has become a given, a necessary part and parcel of life in a *sensory culture*. With ever new and improved information and marketing technologies, the

way we experience the world has changed dramatically. At best, we now have instantaneous access to large amounts of news, opinion, and information about the world, together with sophisticated and efficient means of communication that were unthinkable in previous decades and centuries. At worst, the innate human capacity for reflection, receptivity, interior silence, and the docility of contemplation has steadily eroded. In the attempt to keep pace with the incessant traffic of information, images, and sounds, the ability to listen attentively, to see meditatively, and to read prayerfully diminishes. As our physical senses through which we experience the world are overloaded with multiple images and relentless sound, our "spiritual senses" through which we experience God are increasingly deprived of exercise, nourishment, and light.

Lectio Divina — Purifying the Senses for God

In contrast to this high-speed visual culture, the Christian spiritual tradition of *lectio divina* offers a distinctly different way of reading and hearing. This ancient approach to God's Word also stands apart from biblical exegesis, hermeneutics, and the theological study of Scripture; *lectio divina* is a spiritual reading of Scripture that attunes the "spiritual senses" to listening to God silently, to reading God's Word meditatively, and to resting in His presence. The key is to advance, with the Holy Spirit, in union and intimacy with Jesus Christ, the living Word made flesh, through the mystery of His life, death, and Resurrection.

In recent years, several excellent books and resources on *lectio divina* offer fresh insight into its history, biblical roots, and practice through the centuries. With renewed interest, biblical scholars, theologians, and writers on

monastic spirituality today approach *lectio divina* from a variety of perspectives and emphases.

And this ancient Christian practice, applied to the experience of Christian art, can foster a *prayerful seeing* that is integrated into daily prayer, faith, and life. While upholding the *unique* and *privileged* revelation of Sacred Scripture as the inspired Word of God, might the practice of *lectio divina* be extended to aid reflection on masterpieces of Christian art — painting, sculpture, poetry, sacred and religious music, and sacred architecture? Living as we do in a visual culture that surrounds and inundates us with sensory experiences, could we adapt or apply *lectio divina* analogously to artistic works, to give greater familiarity, deeper insight, and renewed understanding of the Gospel expressed in artistic forms?

The answer is yes: a way of seeing and hearing shaped by *lectio divina*, so different from that which we experience in our sensory culture, can guide how we engage long-recognized masterpieces of Christian art. It can transform the way we see the world as the handiwork of God, the Divine Artist . . . and how we uphold the dignity of the human person, made in God's image, as the crown of creation.

In light of this, we will now consider how to adapt the practice and the stages of *lectio divina* to encounters with masterpieces of Christian art — painting, sculpture, mosaic, stained glass, music, and architecture. The goal of this adaptation is to help the reader acquire a new and deeper capacity to appreciate masterworks of Christian art, to "fine-tune" and open the senses to transcendent mystery. When adapted for encounters with works of

Christian art today, *lectio divina* helps to purify the senses as it leads the viewer to see Christ with the "eyes of faith," and to hear His Word "with the ears of the heart," as St. Benedict urges his monks in the Prologue to his Rule.

Why Adapt *Lectio Divina* to Encounters with Christian Art?

Strictly speaking, *lectio divina* is a Christian practice that focuses on reading of Sacred Scripture. Adaptation of *lectio divina* to encounters with Christian art, however, does not diminish or undermine the unique and privileged revelation of Sacred Scripture as the inspired Word of God. Nor does it mean to suggest that Christian art possesses the same revelatory character as Sacred Scripture and Tradition. Sacred and religious art is a secondary and complementary, not equivalent, expression of the revealed truths of Sacred Scripture. Masterpieces of Christian art — however beautiful, historically important, and culturally valuable — are human creations that express, illustrate, reflect, and radiate divine beauty. Sacred Scripture, although expressed in human words through inspired human authors, is not a human creation. The Church always "welcomes it not as a human word, but as what it really is, the Word of God" (1 Thess 2:13, cf. *CCC* 104).

This adaptation of *lectio divina*, then, has a more pastoral, catechetical, and spiritual objective. It aims to assist the reader to better appreciate and integrate the rich heritage of Christian art — to acquire a new and deeper capacity for childlike wonder, to see with the "eyes of faith" and hear with the "ears of the heart." Following the pattern of *lectio* invites one to integrate intellect, emotions, will, and the senses into a personal appropriation of God's

Word, guided and nourished by the Church. Inspired by Eastern Christianity's honored tradition of prayer in the presence of icons, this application of *lectio divina* extends this spiritual practice to all genuine Christian masterworks of sacred and religious art.

Finally, a way of seeing and hearing informed by *lectio divina* provides a Christian alternative to the multiple and dehumanizing distractions of a fast-paced sensory culture. Shaped by *lectio divina*, the reader is led to focus not only on the Christian themes reflected in a painting, mosaic, stained glass, sculpture, a piece of sacred music, or sacred architecture, but on what is "seen" or "heard" *through* such works of art. And perhaps even ravished, so to speak, by the divine beauty of Trinitarian love revealed in the human face of Jesus Christ, the Word made flesh. In this way, Christian art can become once again a visual Gospel in today's visual culture.

Lectio Divina — From Reading to Contemplation of God

One of the earliest Christian writers to use the phrase *lectio divina* was Origen, a second-century philosopher and theologian. Origen proposed that to gain informed insight and wisdom into the spiritual meaning of Scripture, one needs to read the Bible in prayerful silence, in attentive listening, and with humility and persistence. From early Christian history, we learn that while the practice of *lectio divina* was known to lay men and women, it was in the early religious and monastic communities of monks and nuns that the steady exercise of *lectio divina* thrived. Encouraged in the monastic rules of Sts. Basil, Benedict, and Augustine —

to name a few — *lectio divina*, together with liturgical prayer and manual labor, became the foundation of early Christian monasticism. Through centuries of monastic observance to the present day, *lectio divina* is the rich soil in which monastic reading of Scripture, spiritual reading, reflection, and prayerful contemplation is nourished.

For example, in Chapter 48 of the Rule of St. Benedict, we read these words:

> Idleness is the enemy of the soul. Therefore the brothers should have specified periods for manual labor as well as for prayerful reading (lectio divina).

This exhortation is followed by precise times during the daily and Sunday *horarium*, or monastic schedule, for *lectio divina*.

Additionally, the Rule of St. Benedict (chapters 8:3 and 48:23) outlines "steps" or "stages" of this monastic practice. *Lectio divina* consists of unhurried and silent reading (*lectio*), prayerful reflection (*oratio*), and meditation (*meditatio*) that includes repetition, memorization, and slow "ruminating" of the sacred words or spiritual text. Through this spiritual practice, the monk is led to prayerful assimilation of God's Word and a living appropriation of revealed truth in a life of daily conversion.

In the late twelfth century, a contemplative monk named Guigo II (1140-1193) outlined *The Ladder of Monks*, or *Scala Claustralium*. It consisted of four "stages" or "steps" that have been commonly used since to describe the process of *lectio divina*. Commentators on *lectio divina* often note that these "steps" are not to be seen in a purely

linear way but as a series of unfolding circles of prayer and deeper union with God.

Excerpts from Guigo II's description of the "Four Rungs" of *The Ladder of Monks* trace the foundations of *lectio divina* in the monastic tradition:

The Four Rungs of the Ladder

> One day when I was busy working with my hands I began to think about our spiritual work, and all at once four stages in spiritual exercise came into my mind: reading, meditation, prayer and contemplation. These make a ladder for monks by which they are lifted up from earth to heaven. It has few rungs, yet its length is immense and wonderful, for its lower end rests upon the earth, but its top pierces the clouds and touches heavenly secrets . . .

> Reading is the careful study of the Scriptures, concentrating all one's powers on it. Meditation is the busy application of the mind to seek with the help of one's own reason for knowledge of hidden truth. Prayer is the heart's devoted turning to God to drive away evil and obtain what is good. Contemplation is when the mind is in some sort lifted up to God and held above itself, so that it tastes the joys of everlasting sweetness.

> Reading seeks for the sweetness of a blessed life, meditation perceives it, prayer asks for it, contemplation tastes it. Reading, as it were, puts food whole into the mouth, meditation chews it and breaks it up, prayer extracts its flavor, contemplation is the sweetness itself

which gladdens and refreshes. Reading works on the outside, meditation on the pith, prayer asks for what we long for, contemplation gives us delight in the sweetness which we have found.[2]

Through these steps of "spiritual work," *lectio divina* leads a person from reading (or *lectio*), to meditation (*meditatio*), to prayer (*oratio*), and to contemplation (*contemplatio*).[3]

Reading (or *lectio*), nurtured in silence before God's Word, is the slow, deep, and reverential listening to a biblical word or phrase through which God speaks to our spirit, mind, heart, and will. This slow reading can be an antidote to the sensory overload that often results from the overpowering sensory experiences offered by the media and entertainment culture.

Meditation (*meditatio*) is a silent pondering of the biblical word or phrase that is thoughtfully repeated so it resounds in our memory and finds echo in the faith of the Church. God's past action and presence in our lives enters into the present moment as a lived reality of faith. Meditation engages thought, imagination, emotion, and desire in reflection on God's word (*CCC* 2723).

As a model of meditative prayer, the Christian tradition has always looked to the example of the Mother of God, Mary, as she "pondered all these things in her heart" (Lk 2:19). Early Christian writers liken the one who meditates on God's Word to an animal "ruminating,"

[2] *The Ladder of Monks, A Letter on the Contemplative Life and Twelve Meditations by Guigo II.* Translated with an Introduction by Edmund Colledge, O.S.A., and James Walsh, S.J.. New York: Image Books (Doubleday),1978.

[3] This text is expanded upon in more detail (and in a different translation) at http://www.umilta.net/ladder.html.

or silently chewing food to draw nourishment and strength. Silent and slow meditation on God's Word provides a counterpoint to the relentless pace of human communication demanded by modern technology. The *Catechism* describes the benefits of meditation in this way:

> To meditate on what we read helps us to make it our own by confronting it with ourselves. Here, another book is opened; the book of life. We pass from thoughts to reality. To the extent that we are humble and faithful, we discover in meditation the movements that stir the heart and we are able to discern them.
>
> — CCC 2706

In **prayer** (*oratio*), the biblical word or phrase reverently read and silently meditated upon turns into worship, into prayer that rises from the heart to God. Praying the words of Scripture, we experience the "encounter of God's thirst with ours" (*CCC* 2560). This step of *lectio divina* enters us into the "living relationship of the children of God with their Father who is good beyond measure, with his Son Jesus Christ and with the Holy Spirit" (*CCC* 2565). Words turn into prayer; thoughts and emotions are directed to God. Immersed in God's living Word, prayer is now a humble response of faith, a joyful expression of hope, and a confident trust in God's love.

Contemplation (*contemplatio*) is a silent abiding, a peaceful resting in the presence of God. Simply being in God's presence, rather than doing, is the aim of this stage of *lectio divina*. The one who is immersed in God's Word is now challenged to overcome the temptation to spiritual activism that tends to equate growth in the spiritual life with multiplication of prayers or spiritual activities.

Receptivity to God's grace and openness to the healing power of God's Word replaces anxious self-sustained effort in the spiritual life. In contemplation one's spiritual gaze is simply fixed on the face of Jesus Christ. Growth in holiness and ongoing conversion of the whole of life is now experienced as a pure gift that flows from contemplating the One who reveals God's eternal love. Contemplation, the Catechism tells us, is:

> . . . a *gaze* of faith, fixed on Jesus. . . . This focus on Jesus is a renunciation of self. His gaze purifies our heart; the light of the countenance of Jesus illumines the eyes of the heart and teaches us to see everything in the light of his truth and his compassion for all . . . Words in this kind of prayer are not speeches; they are like kindling that feeds the fire of love.
>
> — CCC 2715-2717

In summary, *lectio divina* is a prayerful reading of the Word of God understood as a "personal act of the Trinitarian God, who loves creation and consequently speaks." God speaks to humanity so that each person might acknowledge his love and respond to Him" (*Lineamenta*, 6). The exercise of *lectio divina* reminds us that the Bible is a sacred word of divine Revelation, a "symphony of divine communication," and the very "speech of God" (*CCC* 81). As a spiritual practice that has flourished in monastic communities for centuries and is now being rediscovered, *lectio divina* may be summarized in this way:

> When the Word of God is read and proclaimed, above all in the Eucharist, the "Sacrament par excellence," and in the other sacraments, the Lord himself makes

an appeal to us to "become part" of a deeply profound and uniquely interpersonal event of communion between him and us and each of us with one another. Truly, the Word of God is active and accomplishes its purpose (cf. Heb 4:12).[4]

"The Word of God is living and active" (Heb 4:12). Through the journey of *lectio, meditatio, oratio,* and *contemplatio* — slow reading, silent pondering, prayerful dialogue, and resting in God — the "spiritual senses" awaken to God's living Word as an active divine presence of wisdom and love.

Adapting *Lectio Divina* to Christian Art: One Example

How might *lectio divina* be applied or adapted in the concrete to an actual encounter with an actual artistic masterpiece? In the following exercise, the reader is invited to join in a *lectio* of a master painting from the National Gallery of Art in Washington, DC. Following this pattern, the reader may then trace the steps of *lectio, meditatio, oratio,* and *contemplatio* with other Christian works of sacred or religious art, be they music, sculpture, stained glass, architecture, or painting.

For purposes of illustration here, we focus on a single masterpiece painting by the Italian artist Giovanni di Paolo titled *The Annunciation and Expulsion from Paradise* (c.

[4] From the document circulated to bishops in preparation for the October 2008 General Synod of Bishops on "The Word of God in the Life of the Church": http://www.vatican.va/roman_curia/synod/documents/rc_synod_doc_20070427_lineamenta-xii-assembly_en.html.

1435). Completed in tempera on panel, the painting is believed to be one of five predella panels that were once part of the lower section of a large Sienese altarpiece. Art historians note that the ornate and stylistically rendered figures and the absence of completely realistic spatial and scale relationships place this work and the painter Giovanni di Paolo within the medieval artistic tradition that took the form of the International Style in the fourteenth and fifteenth centuries.

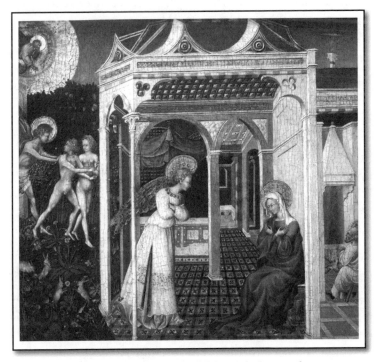

The Annunciation and Expulsion from Paradise

While such historical context, scholarly research, and analysis of the artists' original intentions offer an accurate and informed understanding of a work of art, the goal of applying *lectio divina* here is to go a step further. As we reflect on this Christian masterpiece with the aid of *lectio divina*, the painting emerges as a kind of visual catechesis, or "homily on canvas," on the theological meaning and the spiritual significance of the Annunciation.

The Annunciation and Expulsion from Paradise — A *Lectio Divina*

Lectio

The first step of *lectio divina* is *lectio*, or slow, reverential reading and listening. Christian art that expresses biblical, theological, and spiritual themes in sacred music, painting, sculpture, or architecture may be approached in a similar way. Stilling the mind, eye, and ear in silence predisposes one to "read" or "hear" the work of art, as one would read the pages of a sacred text.

"God is a friend of silence," writes Mother Teresa. In *lectio*, silence creates an interior and exterior space in which a Christian artistic masterpiece breaks through the surrounding distractions to "speak" its sublime word. We are disposed to attend, in simple openness, to the transformative mystery expressed in artistic form. Silence also prepares one to approach the work with the whole being — intellect, will, emotions, and senses.

What do you see in this fifteenth-century painting? What Gospel figure or narrative is depicted? What is the main subject matter taken up by the artist? What secondary

scenes or subjects form part of the scene? Who or what stands at the center of the composition? In the background? In the foreground? What is conveyed through the artist's use of color, line, form, and movement? Keep the painting before you while considering these basic questions as you begin this application of *lectio divina* to this masterpiece of Christian art.

The central area of the panel depicts the main subject of this painting — that momentous Gospel scene (Lk 1:26-38) when the Archangel Gabriel announces to the Virgin Mary that she is to be the Mother of God. To indicate his divine origin, the Archangel Gabriel is shown with golden wings and halo, clothed in a robe of pale red, with hands folded in reverence. The Virgin Mary, seated on a low chair and dressed in a richly folded robe of deep blue, also folds her hands in a gesture of humility while inclining her haloed head to the message of the Archangel Gabriel. Both figures are enclosed within an ornately decorated canopied space. The interior of the house is rendered with a patterned floor tile whose lines recede into the distance. The floor pattern draws the eye instantly into the center of the painting. On the left side, a grassy garden dotted with tiny flowers, rabbits, and green shrubs frames the central scene. In that garden we also see the figures of Adam and Eve, expelled from Paradise by a winged and haloed angel who stands guard at the arched doorway. Above them, in the upper-left-hand corner, a golden sphere encloses an old bearded figure (a traditional depiction of God) whose pointed hand directs an invisible line across the entire scene. Finally, to complete the scene, there is the older St. Joseph, back turned to us, as he warms his hands while seated near a fireplace.

Meditatio

The next step of *lectio divina* is meditation or silent rumination, moving us from the "what" and the "who" to the "why" of the painting. We see with the "eyes of faith" the mystery of faith visually expressed before us. As the painting portrays a Gospel scene, we begin *meditatio* with a prayerful and silent reading of the Scripture passage of the Annunciation (Lk 1:26-38). Word and image sound the first notes in a symphony of meaning revealed in the biblical text. The artist would most likely have read, heard, or been familiar with the same Gospel verses in seeking to give visual expression to the sacred Word. Moving between the sacred text and its visual representation, this silent pondering of both word and image resounds in our memory and finds an echo in the faith of the Church. *Meditatio* draws into the mind, heart, and will the mystery of faith that the image visually communicates.

As we ponder the theological and spiritual meaning of this painting, several questions arise. On what precise biblical moment or moments has the artist focused our attention? What deeper meaning might the artistic technique of linear perspective have in this scene? Does the artist's depiction connect the image to the liturgical celebration of the Annunciation in the Church's calendar? Why has the artist juxtaposed two very different moments of biblical history — Creation and the Annunciation — in one scene? What theological and spiritual meaning lies in the visual connection that places these two biblical scenes side-by-side?

The central area of the panel focuses our attention on the moment when Mary receives the word of the Archangel

Gabriel. Mary's gesture of folded hands and inclined head indicate the moment of her humble openness and receptivity to the angel's message. This is the moment of her *fiat*, her "yes" to God's Word. Mary hears the Archangel's message and experiences the fear and doubt that would naturally accompany such an announcement. But this message is a different one, for it brings with it the fullness of divine Revelation. This is a divine self-communication that echoes in her ears and in her very being. Mary's natural fear is overcome by supernatural grace. And through her "yes," the Word of God himself comes to dwell in her. In this way, Mary teaches the Church how to hear the Word of God: in openness, expectation, docility, and trust. As her fears and doubts transform into joyful trust and faith, Mary shows all those who hear God's Word how to become bearers of God's living presence in the world.

To continue the *meditatio,* notice the use of linear perspective to create the illusion of interior depth and three-dimensional space. The patterned tiles, in linear perspective at the lower center of the painting, lead the eye back into the painting — but also, back into salvation history. On the right side, we see the scene from the opening chapters of the book of Genesis. The biblical scenes from Genesis and the Gospels are placed side-by-side to draw the viewer into the theological meaning of the Annunciation within biblical salvation history. The extended hand of God provides a visual link pointing both to the couple exiled from Paradise and the seated figure of Mary. Adam and Eve's pride, disobedience, and alienation from God are now reversed in Mary's humble "yes" to the Word made flesh. Human pride is overcome by graced humility. Mary, as the early Church Fathers called her, is

the New Eve. Now, expulsion and alienation from God is not the last word on the human condition. Mary's *fiat*, her "yes," is the pivotal word reconciling humanity to God. From then on, Mary's "yes" to God's Word is the believer's *first* word of faith before the mystery of the Incarnation.

Finally, the green foliage, flowers, birds, and rabbits call to mind the spring season when the Annunciation is typically celebrated, each March 25 in the Christian liturgical calendar. St. Joseph warming his hands over a fireplace points to the season of winter, when Christ's birth is celebrated nine months later, on December 25. From left to right, the painting encircles the viewer in the Church's liturgical cycle of feasts and fasts. In a single painting, salvation history — with its key moments of Creation and Annunciation — and liturgical history — with its celebrations of Christ's Incarnation and humble birth — are drawn together as one all-encompassing faith reality.

How does Mary's response of fear, and at the same time confidence and trust, resound in the "book of life" — in your experience, memory, and imagination? How does the painting invite you to imitate Mary's openness to God and response of faith? How does a believer share in the good news of the Annunciation, in Mary's response to the message of the Archangel Gabriel? How is the Church's liturgical calendar brought to life in this painting?

Oratio

In *oratio*, the theological and spiritual meanings mediated by the painting turn into prayer that rise from the mind, heart, and will to God. This step of *lectio divina* guides the

visual, theological, and spiritual content of meditation into prayer as thoughts, emotions, and will are directed to God.

"The Holy Spirit will come upon you and the power of the Most High will overshadow you" (Lk 1:35) are the words of the Archangel Gabriel to Mary at the Annunciation. In the painting, Mary bows her head to incline the "ear of her heart" to listen to the words of the Archangel Gabriel. We see in visual form the theological truth that the Mother of God is the first Christian disciple whose life is so taken over, so inwardly seized by the power of the Holy Spirit. Through meditation and prayer, we come to see that Mary teaches the Church — and every Christian — how to pray. Her receptivity to God's Word and openness to the transforming work of the Holy Spirit is the pattern of fruitful Christian prayer. From the New Eve, we learn how to hear and respond to God's Word with humility, expectation, and trust. The painting offers us a visual catechesis on the human response of faith to God's Word through the offering of the uncertainties, fears, joys, and anxieties of life. In this way, this Annunciation scene serves as a concrete image for the spiritual life and a visual reminder of the Christian vocation to prayer.

Contemplatio

The final step of *lectio divina* applied to a masterwork of Christian art is contemplation. This step of *contemplatio* involves a resting in the mysteries of faith artistically expressed in the painting. To contemplate the scene of the Annunciation is to stand in awe before the mystery of the Incarnation, the centerpiece of Christian faith. We contemplate the mystery of Mary's unique role in salvation history, the divine humility by which God enters

human history through His Son, Jesus Christ, and the Church's liturgical seasons that make present in time these mysteries of faith. Color, line, light, and form draw us to fix our gaze on Christ, whose birth is announced, and whose Incarnation in human history reveals the fullness of divine love. We do not see Christ physically present in this painted image, but we "see" Him with the "eyes of faith," announced by the Archangel Gabriel and humbly received in the mind, heart, and body of the Virgin Mary. With the eyes of faith, the believer has moved from seeing to contemplation to worship, from pondering to prayer to a resting of the mind and spirit in the saving mystery of the Incarnation.

Lectio Divina and Christian Art: From Seeing to Contemplation to Adoration

Adapting *lectio divina* for deeper understanding and appropriation of masterpieces of Christian art, as set forth in the example above, aims to assist the reader to cultivate the capacity to see with the "eyes of faith" and hear with the "ears of the heart." Through the pattern of *lectio divina*, the reader integrates the senses of sight, hearing, and touch for deeper union with God through prayer, participation in the Eucharist, and ongoing faith formation. An approach to seeing and hearing informed by *lectio divina* provides a Christian alternative, or one antidote, to the multiple distractions of a fast-paced sensory culture. It opens us to the transforming power of genuine artistic beauty so that we can begin to see, hear, and touch something of the radiating divine beauty expressed in Christian sacred and religious art.

Shaped by *lectio divina*, the believer is also compelled by what is "seen" or "heard" *through* works of art — to stand

in awe and wonder, to be permeated in mind and body and spirit by the divine beauty of Trinitarian love revealed in the human face of Jesus Christ. In this way, Christian art becomes a visual Gospel within contemporary culture.

The spiritual benefits of adapting *lectio divina* to encounters with Christian masterpieces are summed up well in a Pastoral Note of the Tuscan bishops, *Life Is Made Visible: The Communication of the Faith Through Art*, February 23, 1997 (Articles 9-11), which states:

> The ultimate purpose of art in the life of the Church is to help establish a contact that can be characterized as prayer, contemplation and adoration. Even Gregory the Great, defender of the didactic function of images in a church setting, insists that believers should in the end pass from the *visio* to *adoratio*. It is one thing to adore a painting and quite another to learn from a scene represented in painting what truly we should adore. . . . Narrative images will touch peoples' feelings when personages depicted therein clearly display their own emotions. Nature takes over which is ever in search of things like herself. This is the relationship of exemplarity — through the immediacy of images the Church can propose the example of our Lord's life, the life of the Blessed Virgin and of the saints. In this way, images become one of the means Christians use to communicate the truth they have received In practice in every period of the Church's history, Christian art has been conceived as a means of communication able to bear witness to the heritage given to those who live in the truth. In this light communication of the faith through art is both a ministry and a form of witness.

A THEOLOGICAL DEFENSE OF CHRISTIAN ART

The adaptation of *lectio divina* outlined in Chapter Two returns us to questions raised at the outset of the book. What happens when pastors, teachers, catechists, and evangelists disregard the "unwritten tradition" of Christian art, while the media and entertainment culture effectively uses images, words, and sounds to market and sell products, values, and lifestyles?

What follows will give the reader four reasons why beauty, in the form of Christian art, can in fact be recovered as a visual Gospel for the faithful immersed in our present culture.

A first reason to consider Christian art as a visual Gospel for a visual culture is theological. More precisely, it is Trinitarian and Christological. But why begin with theology? Because theology grounds the integration of Christian art in biblical and spiritual principles of the Christian tradition, rather than as an imitation or accommodation to secular culture. Scripture and Tradition, not the Information Age, inform how and why Christian art can be reclaimed as a visual Gospel. Effective pastoral practice flows from sound theology that sheds light on the integral place of Christian art in liturgy, catechesis, and evangelization.

Christian Art Speaks the Language of the Incarnation

The Trinity of divine Persons — Father, Son, and Holy Spirit — in whose name every Christian is baptized is the theological starting point for reflection on the place and enduring value of Christian art. The Incarnation makes visible the invisible life of the Triune God. The Paschal Mystery of the life, death, and Resurrection of Jesus Christ draws a believer, through the power of the Holy Spirit, into communion with Christ; into the community of believers that is the Church; and, through Christ, into the Trinitarian mystery itself.

The pastoral and spiritual implications of believing in a Trinity of divine Persons and in the Incarnation invite reflection on the role of the arts in the life of the Church. The contemporary relevance of Christian art must also be pondered in this theological light.

The central belief of Christianity — the Incarnation of God in human history in the person of Jesus of Nazareth — provides the theological basis for all forms of Christian art. This theological foundation was expressed well at the Second Council of Nicea (AD 787) that upheld the veneration of images as a necessary outcome of belief in the Incarnation. From the eighth century, also, comes one of the clearest theological articulations in defense of sacred art, in the writings of the Orthodox theologian St. John of Damascus. His treatise *On the Divine Images*, written in the early eighth century, provides the definitive Christian response to the iconoclasts — those who purged churches of Christian iconography, opposed the making of Christian images, and persecuted Christians who defended images.

St. John Damascene's theological arguments against the iconoclasts of his day focus on the decisive change that takes place in the relationship between God and material creation after the Incarnation. He also offers an important distinction between the worship and adoration due to God alone, and veneration or honor proper to the Mother of God, the saints, and sacred books, icons, and relics. In his First Oration, St. John summarizes a theology of Christian images in this way:

> In former times, God who is without form or body could never be depicted. But now, when God is seen in the flesh conversing with men, I make an image of the God who I see. I do not worship matter, I worship the Creator of matter who became matter for my sake . . . who worked out my salvation through matter.
>
> — *On Divine Images*, 17

The Incarnation radically changes God's relationship with humanity. The way humanity relates to the created and material world is also fundamentally altered. And while faith in Jesus Christ as the Son of God first took oral and written forms in the books of the New Testament, the Gospel subsequently took visual and unwritten forms in spontaneous expressions of Christian art that would accumulate over centuries. These unwritten traditions in artistic forms have since also expressed, communicated, and nourished Christian faith. In speaking of sacred icons, the Second Council of Nicea affirmed that "we preserve intact all the written and unwritten traditions of the Church which have been entrusted to us. One of these traditions consists in the production of representational

artwork, which accords with the history of the preaching of the Gospel" (*CCC* 1160).

Pope Benedict XVI summarizes the primary theological principle underlying all genuine expressions of Christian art when he notes, "The complete absence of images is incompatible with faith in the Incarnation of God." Similarly, in his 1999 *Letter to Artists*, Pope John Paul II observed, "The Church must strive to speak the language of the Incarnation expressing with material elements Him who deigned to inhabit matter and to accomplish our salvation with material means." Christian art speaks the language of the Incarnation.

Divine Beauty and Christian Revelation

In the Gospel of John, Jesus affirms that "He who has seen me has seen the Father" (Jn 14:9). The Trinitarian unity of divine persons is here expressed in terms of "seeing" God through His Son. For in the person of Jesus Christ the whole divine reality shines forth in visible form. As the Son of God, Jesus "images" perfectly the Father's love for the world; He perfectly embodies and illustrates God's invisible love in visible form. In the unfolding of God's plan of salvation in Christ's life, death, and Resurrection, divine love takes the form of radiant beauty. This divine beauty elicits the human response of faith and is given material form in works of Christian art.

Christ, the Icon of God

St. Paul sheds light on the unique way in which the Incarnation inspires genuine sacred and religious art when he writes, "He [Christ] is the image (*eikon*) of the

invisible God" (Col 1:15). The person of Jesus Christ is the Icon — the image — of the unseen God. This is why the Incarnation introduces a "new economy of images" (*CCC* 2132). Now Christian art, through which the invisible mystery of God becomes visible, is an essential part of Christian worship, faith, and spirituality.

In his seven-volume work *The Glory of the Lord*, the Swiss theologian Hans Urs Von Balthasar presents a "theological aesthetics" in which divine beauty is the theological framework for receiving and understanding the Revelation of God in Jesus Christ. But how does beauty becomes a context for theological reflection on divine Revelation? Von Balthasar explains that "the beautiful brings with it a self-evidence that enlightens without mediation . . . the criterion of truth (of both divine and total human truth, as well as of supernatural and natural truth) is beauty" (*GL* I:37, I:92). Works of Christian art that show forth the beauty of divine Revelation and the mysteries of faith extend this theological principle into human experience. To receive in faith the divine Revelation of the Trinitarian God in the person of Jesus Christ is to apprehend the beauty of faith.

Imitating the Divine Pedagogy of Word and Image

God's Revelation shapes not only the content of evangelization and catechesis but the methods by which that Revelation is shared with believers and with the world. In Catholic theology, divine Revelation is understood as the self-communication of God in human history, transmitted in Sacred Scripture and Tradition. This divine self-disclosure gradually unfolds in a Divine Pedagogy[1] —

[1] Vatican Congregation for the Clergy, *General Directory for Catechesis*, nos. 139-147.

that is, the concrete means by which God communicates, teaches, and nurtures a covenant relationship with humanity.

The *Catechism of the Catholic Church* describes the various expressions of this divine pedagogy when it notes:

> Even before revealing himself to humanity in words of truth, God reveals himself through the universal language of creation, the work of his Word, of his wisdom: the order and harmony of the cosmos — which both the child and the scientist discover — "from the greatness and beauty of created things comes a corresponding perception of their Creator," "for the author of beauty created them."
>
> — *CCC* 2500

In the Incarnation, the divine pedagogy unfolds in human history in the person of Jesus Christ, the Word made flesh. The Word of God, Jesus Christ, is the Icon, the image of the unseen God. This divine pedagogy is disclosed in a symphony of "words" and "deeds," of divine word and image that engages the whole human person in the response and relationship of faith. This divine pedagogy of "word" and "image" also shapes the various means by which the Church expresses and communicates her faith to believers and to the world.

Christian Art — A Concrete Mode of Catechesis

Pope John Paul II drew attention to the pedagogical value of sacred images in his 1999 *Letter to Artists,* in which he wrote, "In a sense, art is a kind of visual Gospel, a concrete mode of catechesis." Which is to say that each Sunday,

as the faithful hear the Gospel proclaimed and respond by professing their faith in the articles of the Creed, those very truths of faith take the form of the beautiful in works of sacred and religious art that surround them. Church teachings and doctrines, condensed onto a page of a Catechism, find complementary forms of expression in sacred art, music, and architecture. One example of Christian art as a "concrete mode of catechesis" was the group of elaborate medieval illuminated books of Gospel images, known as *Biblia Pauperum*, that would greatly influence the development of Christian art.

One of the first to affirm this role of sacred images was Pope St. Gregory the Great. In a letter written to Serenus, bishop of Marseilles, he said: "Painting is employed in churches so that those who cannot read or write may at least read on the walls what they cannot decipher on the page" (*Epistulae*, IX, 209; AD 599). Written or spoken words and sacred art led the faithful from seeing to contemplation to adoration of God.

Pope Gregory's observation took visible form in the outpouring of Christian art and architecture during the Middle Ages, the age of Christian faith. A Gothic cathedral such as Chartres (c. 1194) served, in effect, as a "catechism in stone" and a "homily in stained glass," expressing for the faithful in art and architecture the faith they professed in the Creed and heard proclaimed in the Scriptures. As medieval craftsmen placed stone upon stone, visible from miles around and radiant with colored glass, they were, in fact, sculpting and painting salvation history — explicit and compelling as their own faith. Consequently, pilgrims entering Chartres Cathedral were drawn not only into a "reading" of past biblical history made visible in sacred

art and architecture but were, through their seeing and hearing, inserted into a sacramental present fully realized in the Eucharist.

While visiting Chartres in the 1950s, Soetsu Yanagi, the father of the Japanese Crafts movement of the early twentieth century, stood in awe before its great stone façade. Then, turning to a Christian friend, he noted: "This is what you have lost today."

Chartres Cathedral remains the best-preserved Gothic masterpiece in Europe today, with most of its original stained glass and sculpture still intact. Masterworks of Christian sacred and religious art and architecture such as Chartres Cathedral, with their eloquent craftsmanship, remind us of the essential place of beauty in liturgy, preaching, and ongoing faith formation. Centuries after they were first created, they continue today to attract, inspire, instruct, and witness to the beauty of faith.

Jesus the Teacher

More than half the Bible comes to us in the form of narratives — a mosaic of interlocking stories that unfold Creation; the Fall; the Exodus; Israel's prophets, patriarchs, and kings; the life, death, and Resurrection of Christ; and the birth of the Church. The divine pedagogy of word and deed moves through salvation history in narrative form as a drama of the divine-human relationship. Through the centuries, artists have found in this biblical narrative a rich source of inspiration and creativity.

As Pope John Paul II noted in his 1999 *Letter to Artists*:

Sacred Scripture has become a sort of "immense vocabulary" (Paul Claudel) and "iconographic atlas"

(Marc Chagall), from which both Christian culture and art have drawn. The Old Testament, read in light of the New, had provided endless streams of inspiration. From the stories of Creation and sin, the Flood, the cycle of the Patriarchs, the events of the Exodus to so many other episodes and characters in the history of salvation, the biblical text has fired the imagination of painters, poets, musicians, playwrights and film-makers. . . . From the Nativity to Golgotha, from the Transfiguration to the Resurrection, from the miracles to the teachings of Christ, and on to the events recounted in the Acts of the Apostles or foreseen by the Apocalypse in an eschatological key, on countless occasions the biblical word has become image, music and poetry, evoking the mystery of the "Word made flesh" in the language of art.

In fifty or more New Testament passages, Jesus is given the title "Teacher." Inspired by these biblical passages, artistic portrayals of "Christ the Teacher" may be traced as far back as the Roman catacombs of the second and third centuries. In time, the image of "Christ the Teacher" appears in Romanesque and Byzantine art, and later emerges as a key motif in the sacred art and architecture of Gothic and Renaissance cathedrals.

As a divine teacher, Jesus draws on narrative forms in the Old Testament, particularly in his parables, rich with multiple levels of meaning and pointing to deep spiritual truths. And at the heart of each Gospel parable are distinct images painted with words. A few examples from the Gospels illustrate the point.

When Jesus teaches about divine forgiveness and mercy, He paints the moving image of the Prodigal Son

returning to the embrace of a father's unrelenting love. When Jesus explains the necessity of faith, He draws on agricultural images — the parable of the mustard seed (Mt 13:31), the lost sheep (Mt 18:10), the birds of the air that surpass the beauty of Solomon's clothing (Mt 6: 29), the pearl of great price (Mt 13:45), and the sower and the seed (Lk 8:9-15).

At the Last Supper, Jesus' teachings bear the deeper character of personal witness. Now, Jesus instructs the disciples on the meaning of servant love and washes their feet, as the Church recalls in the liturgy of Holy Thursday. In this pivotal Gospel moment, during which Jesus anticipates His suffering and death on the Cross and institutes the Eucharist, we see His words and actions join together to reveal to the disciples the most genuine form of servant discipleship — the total gift of self in love.

Educators, catechists, evangelists, and preachers who draw inspiration from the witness of Jesus the Teacher will look to the "divine pedagogy" that unites word, deed, and image. This inner unity between word, deed, and image also finds full expression in the Catholic sacramental tradition.

Christian Art: A "Pre-sacrament"

The *Catechism of the Catholic Church* notes:

> *Sacred art* is true and beautiful when its form corresponds to its particular vocation: evoking and glorifying, in faith and adoration, the transcendent mystery of God — the surpassing invisible beauty of truth and love visible in Christ, who "reflects the glory of God and bears the very stamp of his nature," in whom "the whole fullness of deity dwells bodily. . . .

> Genuine sacred art draws man to adoration, to prayer,
> and to the love of God, Creator and Savior, the Holy
> One and Sanctifier.
>
> — *CCC* 2502

To move the viewer from seeing, to contemplation, to adoration of God is the primary role of sacred and religious art. An artistic image of Christ, the Mother of God, a biblical event, or Christian saint provides an earthly glimpse into eternal realities, a "head start to heaven," so to speak. The adaptation of *lectio divina* for encounters with Christian art, discussed in Chapter Two, provides one concrete way for the reader to make this journey from seeing to contemplation to adoration.

The *Catechism* describes the goal of "liturgical catechesis (mystagogy) that aims to initiate people into the mystery of Christ by proceeding from the visible to the invisible, from the sign to the thing signified, from the 'sacraments' to the 'mysteries'" (*CCC* 1075). Instituted by Christ, the sacraments are the privileged means by which the faithful participate in His saving work through the ministry of the Church. Sacramental celebrations are woven from signs and symbols — water, bread, wine, oil — rooted in creation and human experience, specified by events in salvation history, and fulfilled in the saving work of Christ. To participate sacramentally in God's saving work in Christ corresponds to the way we are created — as a unity of body, mind, and spirit. To participate in the Sacraments of the Church is to be engaged as a whole human person — intellect, will, body, and senses — in the response and life of faith.

Within the Catholic sacramental tradition, sacred art in particular, created for the liturgical context, predisposes

one to the sacramental presence of God. Experienced within the Eucharist, sacred art serves as a "pre-sacrament," a phrase used by Pope John Paul II to describe the sacred art and architecture of the Sistine Chapel.

To limit the function of sacred art to decorative or aesthetic representations of past religious and socio-cultural ideals, then, is to miss a high note in the liturgical symphony that is composed of sacred rites, images, architecture, and music. Certainly, sacred and religious images, music, and architecture aesthetically enhance the interior and exterior spaces of cathedrals, chapels, and churches. But a work of sacred art is also indispensable as a pre-sacrament, as it reawakens and nourishes the faith of believers while preparing them to understand and live the meaning of the sacraments they celebrate.

Summary

Evangelization, catechesis, sacramental preparation, and ongoing faith formation that integrates Christian art reflects and imitates the divine pedagogy of "word," "deed," and "image," to invite the whole human person to the beauty of faith. By drawing on Christian artistic masterpieces, parents, preachers, catechists, teachers, and spiritual formators echo the divine pedagogy of salvation history, in which God's "words" and "deeds" are inextricably linked. The adaptation of *lectio divina* for encounters with sacred and religious art, as presented in Chapter Two, offers one concrete and pastoral means by which Christian art can serve as such a visual Gospel.

The Trinity and the Incarnation, and a Catholic sacramental worldview that unites intellect, will, and senses, provide the theological basis for integrating

Christian art in liturgy, catechesis, and evangelization. In his treatise on *The Incarnation of the Word of God*, St. Athanasius, theologian and early defender of Christianity, summarizes well the theological basis for this renewed integration of Christian art:

> The Savior of us all, the Word of God, in His great love, took to Himself a body and moved as a man among men, meeting their senses, so to speak, halfway. He became himself an object for their senses, so that those who were seeking God in sensible things might come to knowledge of the Father through the works which He, the Word, did in the body. (15)

CHRISTIAN ART IN HUMAN EXPERIENCE

I have learnt to love you late, Beauty at once so ancient and so new! I have learnt to love you late! You were within me, and I was in the world outside myself. I searched for you outside myself and, disfigured as I was, I fell upon the lovely things of your creation. You were with me, but I was not with you. The beautiful things of this world kept me far from you and yet, if they had not been in you, they would have had no being at all. You called me; you cried aloud to me; you broke my barrier of deafness. You shone upon me; your radiance enveloped me; you put my blindness to flight. You shed your fragrance about me; I drew breath and now I gasp for your sweet odour. I tasted you, and now I hunger and thirst for you. You touched me, and I am inflamed with love of your peace.[1]

Not many of us would describe our experience of God with these dramatic images. Yet in this stirring passage from his *Confessions* (Book X, 27), the great bishop and Doctor of the Church tells of being overwhelmed with God's love.

As human beings, we are made for beauty. And Augustine's vivid description of a personal encounter

[1] St. Augustine, *Confessions* (Penguin Classics, translated by R.S. Pine-Coffin. London [UK]: Penguin Books, 1961: 231-232).

with divine Beauty, cast in sensory terms, also offers a distinctly Christian view of the human person — that is, a Christian anthropology. Augustine's sublime words lead us to ask: what is the nature of the human person capable of encountering God through "seeing," "hearing," "smelling," and "tasting" divine love?

If the contemporary recovery of Christian art within a visual culture is grounded first in Christian theology, then a second rationale is this Christian anthropology. Every religious tradition assumes a distinct anthropology in its view of the origin, dignity, and purpose of the human person. Each anthropological perspective speaks, in strikingly different ways, to the place of art in worship, evangelization, and spiritual and faith formation. A Christian anthropology, rooted in Sacred Scripture and Tradition, distinctly shapes the integration of art in liturgy, catechesis, and the evangelization of culture.

Pedagogy of the Senses

The *Rite of Christian Initiation of Adults* (*RCIA*) marks the journey of adults who are initiated into the Catholic Church through the sacraments of Baptism, Confirmation, and Eucharist. Traced back to their early Christian origins in the baptismal catechumenate of the third and fourth centuries, these rites of sacramental initiation were recovered in our time at the Second Vatican Ecumenical Council (1962-1965).

In an unfolding progression of initiatory rites and scripture readings, the main periods and steps of the *RCIA* are the Period of Evangelization and PreCatechumenate, with a first step of Acceptance into the Order of Catechumens; the Period of the Catechumenate, with a

second step of Election or Enrollment of Names; a third Period of Purification and Enlightenment, culminating in the Easter celebration of the Sacraments of Initiation; and a fourth Period of Post-Baptismal Catechesis or Mystagogy.

During the Rite of Acceptance into the Order of Catechumens we find a ritual moment called the "Signing of the Senses" (*RCIA*, 56). The catechist or sponsor makes the Sign of the Cross on each of the candidates' senses — ears, eyes, lips, heart, shoulders, hands, and feet — accompanied by these words:

> Receive the sign of the cross on your ears,
> that you may hear the voice of the Lord.

> Receive the sign of the cross on your eyes,
> that you may see the glory of God.

> Receive the sign of the cross on your lips,
> that you may respond to the Word of God.

> Receive the sign of the cross over your heart,
> that Christ may dwell there by faith.

> Receive the sign of the cross on your shoulders,
> that you may bear the gentle yoke of Christ.

> Receive the sign of the cross on your hands,
> that Christ may be known in the work you do.

> Receive the sign of the cross on your feet,
> that you may walk in the way of Christ.

I sign you with the sign of eternal life
in the name of the Father, and of the Son,
and of the Holy Spirit.[2]

This simple and eloquent initiatory rite of "blessing the senses" ritually speaks a distinct Christian anthropology. The human person, created in the image of God, is a being at once corporeal and spiritual, an embodied spirit. As a unity of body and spirit, human beings express and perceive spiritual realities through tangible signs, most especially sacramental signs and symbols. Consequently, the embodiment of the human person is not considered an accident of nature or a byproduct of random molecular combinations. Rather, our embodiment, as creatures willed by God, is a necessary pre-condition for receiving God's revelation and for the human response of faith. The human person, created by God out of love, is a gift of love to be given to others out of love. And the way God communicates with humanity corresponds to the way we were created — as embodied spirits.

Faith Comes through Hearing

From a Christian anthropology that views the human person as an embodied spirit flows an understanding of the act of faith itself. Christian faith is the free response of the whole human person — intellect, will, memory, emotions, and senses — to God who reveals. St. Augustine's experience of God, described at the beginning of this chapter, expresses well this anthropological reality. It should not surprise the reader that Augustine describes "seeing," "hearing," "smelling," "touching," and "tasting"

[2] *Rite of Christian Initiation of Adults,* © 1985, International Committee on English in the Liturgy, Inc.

the divine beauty of God. His poetic description conveys an important Christian idea: the human person, created by God as a unity of body, mind, soul, and spirit, responds in faith to divine Revelation in that same unity.

As Edward Oakes has observed:

> It is in an analysis of the nature of beauty that we see how sight and hearing can be fused into one total assent to God's gifts of creation and revelation…Beauty by its very nature always elicits a response; one simply cannot experience a form or phenomenon as beautiful without responding, without assenting.[3]

Faith, then, is the free assent to God of the whole human person. And while evangelization, catechesis, and ongoing faith formation may lead a person to what Cardinal Newman called a "notional assent" to the mystery of the Incarnation, the journey of Christian faith does not stop there. Effective evangelization and ongoing catechesis move a person, in Newman's term, to "real assent" that encompasses mind, heart, will, emotions, and senses. Sound catechesis, effective evangelization, and preaching engage and move the whole human person through lifelong conversion and discipleship.

The Spiritual Senses and the Arts

In October 2008, bishops from around the world gathered in Rome to reflect on and discuss "The Word of God in the Life and the Mission of the Church." During this General Synod, several reflections — or "interventions," as they are called — were presented on the opportunities

[3] Edward Oakes, *Pattern of Redemption* (New York: Continuum, 1994), 136-142.

and challenges facing the Church as she guards, interprets, proclaims, teaches, and preaches the Word of God.

One of the synod interventions delivered by the Ecumenical Patriarch Bartholomew I in the Sistine Chapel calls to mind the early Christian doctrine of the "spiritual senses, or the five senses of the soul." The homily invites reflection on how sacred and religious images call us to another way of seeing the world, our neighbor, and even reality itself. It also points to the close link between the doctrine of the "spiritual senses" and Christian art and offers an anthropological basis for a recovery of Christian art as a visual Gospel.

The Ecumenical Patriarch Bartholomew I described the "spiritual senses" in these words:

> More concretely we should like to concentrate on three aspects of the subject, namely: on hearing and speaking the Word of God through the Holy Scriptures; on seeing God's Word in nature and above all in the beauty of the icons; and finally on touching and sharing God's Word in the communion of saints and the sacramental life of the Church. For all these are, we think, crucial in the life and mission of the Church. In so doing, we seek to draw on a rich Patristic tradition, dating to the early third century and expounding a doctrine of five spiritual senses. For listening to God's Word, beholding God's Word, and touching God's Word are all spiritual ways of perceiving the unique divine mystery. Based on Proverbs 2.5 about "the divine faculty of perception (αἴσθησιν)," Origen of Alexandria claims: This sense unfolds as sight for contemplation of immaterial forms, hearing for discernment of voices,

taste for savoring the living bread, smell for sweet spiritual fragrance, and touch for handling the Word of God, which is grasped by every faculty of the soul. The spiritual senses are variously described as "five senses of the soul," as "divine" or "inner faculties," and even as "faculties of the heart" or "mind." This doctrine inspired the theology of the Cappadocians (especially Basil the Great and Gregory of Nyssa) as much as it did the theology of the Desert Fathers (especially Evagrius of Pontus and Macarius the Great). . . . Nowhere is the invisible rendered more visible than in the beauty of iconography and the wonder of creation. In the words of the champion of sacred images, St. John of Damascus: "As maker of heaven and earth, God the Word was Himself the first to paint and portray icons." Every stroke of an iconographer's paintbrush — like every word of a theological definition, every musical note chanted in psalmody, and every carved stone of a tiny chapel or magnificent cathedral — articulates the divine Word in creation, which praises God in every living being and every living thing (cf. Ps. 150.6).[4]

The patristic doctrine of "five spiritual senses" or "five senses of the soul" recalls that the human person possesses faculties or powers by which we experience the invisible reality of God. Masterpieces of sacred and religious art engage these "spiritual senses" as we contemplate, hear, touch, smell, and taste the beauty of faith that makes invisible realities visible. An encounter with a masterwork of Christian art engages our "spiritual senses" so that we are led from the visible to the invisible, from the sign

[4] Remarks contained in the *Synodus Episcoporum Bulletin,* http://www.vatican.va/news_services/press/sinodo/documents/bollettino_22_xii-ordinaria-2008/02_inglese/b30_02.html.

to the reality signified, from sensory perceptions to the mysteries of faith.

The role of icons in the spiritual and liturgical traditions of Eastern Christianity to engage the "spiritual senses" reminds us of the power of sacred art in human experience. In the words of the Patriarch Bartholomew:

> Icons are a visible reminder of our heavenly vocation; they are invitations to rise beyond our trivial concerns and menial reductions of the world. They encourage us to seek the extraordinary in the very ordinary, to be filled with the same wonder that characterized the divine marvel in Genesis: "God saw everything that He made; and, indeed, it was very good" (Genesis 1:30-31). Icons underline the Church's fundamental mission to recognize that all people and all things are created and called to be "good" and "beautiful.". . . Indeed, icons remind us of another way of seeing things, another way of experiencing realities, another way of resolving conflicts.[5]

Nostalgia for the Nameless

On numerous occasions, Pope Benedict has reflected on the implications of encounters with beauty in nature and art for evangelization, catechesis, and moral and spiritual formation in the Christian life. In an address titled "The Feeling of Things, the Contemplation of Beauty," given in August 2002, then-Cardinal Ratzinger drew on a work by the fourteenth-century theologian Nicholas Cabasilas

[5] http://www.vatican.va/news_services/press/sinodo/documents/ bollettino_22_xii-ordinaria-2008/02_inglese/b30_02.html#SPEECH_ BY_THE_ECUMENICAL_PATRIARCH_BARTHOLOMEW_I.

titled *The Life in Christ*. In that treatise, Cabasilas speaks of that nameless human nostalgia, the unspoken and often unrecognized sense that "something is missing" in the human condition alienated from God. Cabasilas says:

> When men have a longing so great that it surpasses human nature and eagerly desire and are able to accomplish things beyond human thought, it is the Bridegroom who has smitten them with this longing. It is He who has sent a ray of his Beauty into their eyes. The greatness of the wound already shows the arrow which has struck home, the longing indicates who has inflicted the wound.
>
> — cf. *The Life in Christ*, Second Book, 15

That which is beautiful "wounds," Pope Benedict goes on to observe, but this is exactly how it summons human beings to their final destiny in God. To know God is to be struck by the "arrow of Beauty that wounds man," moved by reality. For Cabasilas, beauty is "how it is Christ himself, who is present in an ineffable way, disposes and forms the souls of men" (ibid.). Christ, who is divine Beauty Incarnate, answers this basic human hunger for God.

Cabasilas also distinguishes between two kinds of knowledge. First, there is knowledge through instruction which remains, for the most part, "secondhand," and may not involve direct contact with reality itself. And then there is knowledge through direct encounter with reality — that is, knowledge through personal experience. Pope Benedict underscores that the human encounter with beauty, direct and personal, is a true form of knowledge that invites us to deeper and greater truths.

The knowledge that comes through beauty may not, however, be reduced to a superficial aestheticism, sentimentalism, or irrationalism. In this context, delighting in Rembrandt's religious portraits, Milton's poems, or Handel's *Messiah* cannot be reduced to an indulgence in beauty for its own sake. Nor is knowledge through beauty meant to be a flight from clarity or the importance of reason. Rather, beauty gives knowledge in a different form as it awakens us to deeper and greater truth. This human nostalgia — a sense that "something is missing" from human experience without God — Pope Benedict XVI addressed in these words:

> The beautiful is knowledge certainly, but in superior form, since it arouses us to the real greatness of truth . . . being struck and overcome by the beauty of Christ is a more real, more profound knowledge than mere rational deduction. Of course, we must not underrate the importance of theological reflection, of exact and precise theological thought; it remains absolutely necessary. But to move from here to disdain and reject the impact produced by the response of the heart in the encounter with beauty as a true form of knowledge would impoverish us and dry up our faith and our theology. We must rediscover this form of knowledge; it is a pressing need of our time.[6]

[6] "The Feeling of Things, the Contemplation of Beauty," Address given to Communion and Liberation in Rimini, Italy, August 2002.

Poetic Knowledge and Christian Art

The noted American poet and former chairman of the National Endowment for the Arts, Dana Gioia, has spoken of the need to recover "poetic knowledge" in contemporary education. This form of knowledge engages mind, senses, heart, will, emotions, imagination, and memory to involve the whole person in a process of education aimed at transformation of life. To be educated is more than having or acquiring knowledge for careers of personal success, wealth, and fame. "Poetic knowledge" educates one to become a person transformed by wisdom to serve the truth and dignity of the human person and the good of the human community. This "poetic knowledge" is nurtured by the arts, particularly sacred and religious, when they convey through the senses the moral, spiritual, and social demands of living the Gospel. When applied to faith formation, catechesis, and evangelization, "poetic knowledge" invites the initial and ongoing conversion of the whole person to faith and life in Jesus Christ.

St. Thomas Aquinas points to this unity of intellect, memory, will, and the senses when he offers three reasons for the integration of Christian art in a brief passage from the *Sentences*:

> There were three reasons for the introduction of the use of visual arts in the Church: first, for the instruction of the uneducated, who are taught by them as by books; second, that the mystery of the Incarnation and the examples of the saints be more firmly impressed on our memory by being daily represented before our eyes; and third, to enkindle devotion, which is more

efficaciously evoked by what is seen than by what is heard.[7]

Art Appreciation and Growth in Virtue

Today, people tend to experience masterpieces of Christian art as yet another product to be consumed in the supermarket of visual entertainment. Conditioned by multiple forms of mass entertainment offered by popular culture, even Christian art can come to be viewed as another aesthetic artifact invented for consumption by passive recipients. In this way art appreciation is reduced to a most superficial objective and outcome.

The adaptation of *lectio divina* for Christian art (Chapter Two) points to the deeper spiritual and formational effects of genuine aesthetic experiences that awaken, teach, and nourish faith. One profound effect of art appreciation is in the moral and spiritual life. Dominican Fr. Basil Cole, O.P., offers the following observations (*Logos* 9:3, Summer 2006) on the role of the arts in the spiritual life when he writes:

> The delighting in art works can do many wondrous things for the soul and body. Art works bring delight to soul and body because of the beauty of their formal qualities of composition, through their representation of pleasing images and thoughts, and finally through the engagement of the reader, listener, or viewer with the work of art. The contemplation associated with the fine arts can be supremely delightful, given a way of life that may make heavy demands by reason of work

[7] IV *Sentences*, t.3, d.9, q.1, a.2, and 3m.

and profession. But above all, fine art appreciation acts as an icon for virtue itself, which implies a "doing" or "action" flooded with reason, faith and even at special moments the instigation of the gifts of the Holy Spirit. This is definitely not the intellectual virtue of art but a virtue of the will conducive to a life of the higher virtues.

Experiences of genuine Christian art lead a person across the threshold of beauty to wonder, meditation, and contemplation of divine truths. In nature and in masterworks of Christian art, it is the Good that takes the form of the Beautiful. And, to the extent that one is brought to contemplation through the beauty of a work of Christian art, one is led to the practice and purpose of the virtuous life itself — to a life of virtue, in imitation of Christ, with the help and grace of God.

Seeing with the "Eyes of Faith"

"Blessed are the pure in heart," says Jesus, "for they shall see God" (Mt 5:8). To "see God" is both a supernatural gift and part of the vocation of every Christian (*CCC* 1716-1728). In this Beatitude, however, the capacity to "see God" is explicitly linked to purity of heart. So what does it mean to purify one's heart so as to "see God"?

To "see God" is a desire placed by God in the human heart, our common human desire for transcendence. Our longing for God draws each created person to the One who alone can fulfill it. "Beatitudes teach us the final end to which God calls us; the Kingdom, the vision of God, participation in the divine nature, eternal life, filiation and rest in God," notes the *Catechism* (*CCC* 1726).

But "seeing God" is not simply a promise to be fulfilled in the future, in eternal life and final rest. To grow in purity of heart transforms us in the present as well. In the here and now, the one who purifies the heart through a cleansing of the senses — seeing, hearing, touching — is given an earthly and partial glimpse of God.

Is this not the promise of this beatitude? And is the need to purify the heart by purifying the senses all the more urgently felt by children, youth, and adults immersed in the dominant media and information culture with its fast-paced, fragmented, multiple images and sounds?

One of the great Fathers of the Church, St. Gregory of Nyssa, speaks eloquently of this longing:

> Every desire for the Beautiful which draws on us in the ascent to the infinite is intensified by the soul's very progress towards it. And this is the real meaning of seeing God: never to have this desire satisfied. But fixing our eyes on those things which help us to see, we must ever keep alive in us the desire to see more and more.

> — St. Gregory of Nyssa, *The Life of Moses*

This is where Christian art comes in. For contemplation of divine beauty and the beauty of faith expressed in masterpieces of Christian art provide a concrete way to purify our senses in anticipation of the promised eternal vision of God. Genuine masterpieces of sacred and religious art offer privileged means by which we purify our vision and our heart so as to "see God," now and in the life to come. Pope Benedict affirmed this capacity of Christian art to purify the senses when he observed:

To admire icons and the great masterpieces of Christian art leads us on an inner way, a way of overcoming ourselves; thus in this purification of vision that is a purification of the heart, it reveals the beautiful to us, or at least a ray of it. In this way we are brought into contact with the power of truth. . . . The true apology of Christian faith, the most convincing demonstration of its truth against every denial, are the saints, and the beauty that the faith has generated. Today, for faith to grow, we must lead ourselves and the persons we meet to encounter the saints and to enter into contact with the Beautiful.

— "The Feeling of Things, the Contemplation of Beauty"

THE WITNESS OF HISTORY AND THE CHALLENGE OF THE "CULTURE OF IMAGES"

In the summer of 2008, an unlikely candidate made it to the top of pop music's Top 10 list. The music album, titled *Chant: Music for Paradise*, was sung by seventeen Cistercian monks of the Stift Heiligenkreuz Abbey, Austria. It remained, to the surprise of many, on pop music's Top 10 list, ranking first in the field of classical music for several weeks in the United Kingdom. Over a decade ago, another Gregorian chant recording simply titled *Chant* received similar universal acclaim. Sung by Benedictine monks of Santo Domingo de Silos in northwest Spain and released in 1994, the recording became the best-selling album of Gregorian chant ever released, with over six million copies sold worldwide.

Gregorian chant is an ancient form of sung liturgical prayer, flourishing in the first millennium, and appearing as early as the fourth century. Sometimes called the "song of the angels," and praised as "medicine for the soul," in the words of Cistercian Father Karl Wallner, Rector of the Benedict XVI University of Heiligenkreuz, few music forms are as countercultural as the sacred music of Gregorian chant. Different from most contemporary musical sounds, Gregorian chant stands outside the conventional experience of music and has flourished

mostly in monasteries and convents. So why are people of today, surrounded by secular music of every kind, drawn to this early form of Christian sacred music?

If Christian theology and anthropology offer compelling reasons for a recovery of Christian art as a visual Gospel, then a third incentive is the witness of Christian history, cumulative and undeniable. From the primeval art of the early Christian catacombs and splendid Romanesque basilicas to the brilliance of Byzantine iconography, from soaring Gothic cathedrals to the creative torrent of the Renaissance, from the mysticism of Baroque movement to the abstraction of modern art, the history of Christianity is inextricably linked to its artistic heritage built up over centuries. Reflecting on the enduring historical value of Christian art, Pope Benedict XVI, while speaking to priests, deacons, and seminarians of the major seminary of Bressanone, (August 6, 2008), concluded his address with these words:

> Christian art is a rational art. It is the artistic expression of a greatly expanded reason, in which heart and reason encounter each other. This is the point. I believe that in a certain way this is proof of the truth of Christianity: heart and reason encounter one another, beauty and truth converge, and the more that we ourselves succeed in living in the beauty of truth, the more that faith will be able to return to being creative in our time too, and to express itself in a convincing form of art.

A "Visual Deposit of Faith"

There has never been a time in the history of Christianity when Christian beliefs, piety, and spirituality have not found sensory expression in works of Christian art — sacred and religious art, music and architecture. The historical witness of Christian art is undeniable. But does this witness count for nothing more than an aesthetic "history lesson"?

While there is no doubt that the accumulated artistic heritage of Christianity gives historical insight into past artistic styles, social, political and cultural worlds, it also forms a kind of "visual deposit of faith" that has contemporary relevance for the evangelizing mission of the Church. The accumulated treasury of Christian art did serve aesthetic, social, and political purposes in the past. But it also served to express in sensory forms basic Gospel truths, and to evangelize and form generations of Christians. Those who encountered masterpieces of sacred and liturgical art with the "eyes of faith" were led from seeing to contemplation to worship.

How might this "visual deposit of faith," found in historical treasures of Christian art, invite, inspire, instruct, and form in the Christian faith today? Can the Church's artistic heritage echoing across history, continue to bear witness to the Gospel in our time? Teachers, preachers, evangelists, and catechists who seek concrete ways to integrate the historical heritage of Christian art will resound with a basic dimension of human experience — that of religious imagination rooted in memory. Perhaps the example of renewed interest in Gregorian chant suggests that the historical legacy of Christian art from the

past can serve, even today, as a genuine mode of catechesis and evangelization, a means or channel by which people of today enter into the Christian tradition through the witness of beauty.

As Pope Benedict notes:

> Faith must continuously face the challenge of thought in this era, so that it does not seem a sort of irrational legend that we keep alive, but that which really is a response to the great questions, not merely a habit but the truth. . . . If we contemplate the beauties created by faith, they are simply, the living proof of faith . . . great works of art are all a luminous sign of God and therefore truly a manifestation, an epiphany of God.[1]

The Memory of Beauty

Each year, millions of visitors and tourists journey to museums, cathedrals, churches, and chapels, to encounter historical treasures in the form of sacred and religious painting, sculpture, mosaic, stained glass, music and architecture. Such historical masterpieces that express Christian themes serve as sensory windows into past artistic movements and stylistic approaches and the, often unsurpassed, skill and creative genius of artists through human history. With the eyes of faith, however, their enduring value is so much more than the historical knowledge and insight they provide about past religious, social, cultural, and political worlds. Masterpieces of Christian art, from every age, culture, and people, are

[1] Meeting of the Holy Father Benedict XVI with the clergy of the Diocese of Bolzano-Bressanone, August 6, 2008.

living and "unwritten traditions" that, in every age, continue to bear witness to the Gospel. As Pope Benedict XVI recently observed:

> In every age, Christians have sought to give expression to faith's vision of the beauty and order of God's creation, the nobility of our vocation as men and women made in His image and likeness, and the promise of a cosmos redeemed and transfigured by the grace of Christ. . . . The artistic treasures which surround us are not simply impressive monuments of a distant past. Rather, for the hundreds of thousands of visitors who contemplate them year after year, they stand as a perennial witness to the Church's unchanging faith in the Triune God who, in the memorable phrase of Saint Augustine, is Himself, "Beauty ever ancient, ever new."[2]

Christian Art as a Privileged Means of Evangelization and Catechesis: Two Examples

From deep in the rain forests of Bolivia can be heard today a rare feast of sacred Christian music. Brought to Bolivia by Jesuit missionaries from Spain and Italy in the sixteenth to eighteenth centuries, this unique collection of sacred chant and Baroque vocal, choral, and instrumental music was the primary means by which the Jesuits first evangelized, catechized, and formed the Chiquitos people in the Gospel way of life. In the 1970s and 1980s, restorations of the Jesuit missions of Chiquitos (1691-1767) and Moxos (1681-1767) unearthed nearly 10,000 sheets of Baroque music scores. The remarkable discovery launched

[2] Address of June 1, 2006, to the Patrons of the Arts in the Vatican Museums on the occasion of the 500th anniversary of the founding of the Museum.

a music festival that has since gained worldwide attention and acclaim. Today, an international festival of Baroque music is held every two years to preserve this musical heritage and share it with the world.

In order to effectively share the Gospel with the native peoples, Jesuit missionaries appealed to their natural affinity for music and their superior musical talents. Evangelists and missionaries understood well that the sheer beauty of sacred music would open hearts, prepare minds for Gospel truths, and uplift and unite the soul to God.

Detailed historical records of the Jesuit missions of the sixteenth to eighteenth centuries now reveal that each missionary settlement, or *reduccion*, developed a choir and an orchestra with forty to fifty musicians and singers drawn from the local populations. With daily lessons and practice sessions, they quickly learned to sing and play by heart an extensive and fine repertoire of sacred music. After embracing Christianity, they lived and celebrated the faith they professed in the Creed through music composed for daily Masses, vespers, hymns, motets, carols, sacred operas, sonatas, and other musical forms popular at the time. Consequently, the missionary music schools became for the natives "schools of faith, hope, and love" where the Gospel was shared, lived, and celebrated through exceptional sacred music. Gospel truths touched and converted the heart and soul of a people through the sacred music echoing across their land, as visualized in the opening scenes of the award-winning movie *The Mission*. Christian art, in the form of beautiful music, was a key instrument of the Church's evangelizing mission, of catechesis and ongoing formation in Christian virtue and the spiritual life.

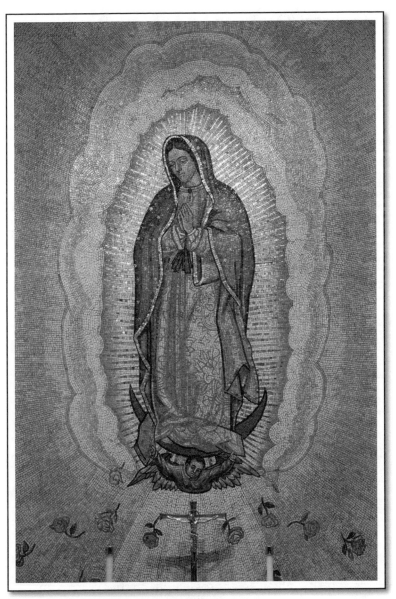

The Virgin of Guadalupe

The Image That Evangelized a Continent

How did vast countries of the continents of South America come to Christian faith within a relatively few hundred years? While successive waves of European missionaries from Portugal, Spain, and Italy carried the Gospel to small regions of these vast lands with varying success, one image effectively sustained and completed the Christian evangelization of the Americas — the image of the Mother of God, the Virgin of Guadalupe, miraculously imprinted on the tilma or cloak of the humble Aztec peasant Juan Diego in December 1531, and venerated to this day in Tepeyac, Mexico.

With this single image, the Church's evangelizing mission spread like wildfire and converted millions to Christianity. Impressed firmly on the religious imagination of the faithful, the radiant maternal image of a pregnant Virgin Mary, depicted as an Aztec woman and clothed in local traditional dress, visually expressed and conveyed the same Gospel truths that generations of missionaries had carried to the New World. Whatever may be said of popular devotions surrounding the image of the Virgin of Guadalupe, the influence of this single sublime image on the Church's missionary, evangelical, and catechetical efforts in the region is historically undeniable.

A Challenge of Culture:
"Making Belief Believable" Today

"My son is addicted to video games and the Internet!' says an exasperated father.

"My daughter is engrossed in celebrity magazines, popular music, and fashion," complains her mother.

"Will a fifteen-minute weekly homily engage parishioners habituated to long hours of passive television entertainment each week?" wonders a pastor.

There is no arguing that we live in the midst of a sensory culture, in which it is not uncommon to speak of "sensory overload" and "sensory addictions." Within this sensory culture, how is the Church to "make belief believable"?

A fourth and final reason for placing Christian art at the service of evangelization and catechesis, then, is a cultural one. Few will disagree that we live in the midst of a global culture in which multiple images dominate, shape ,and define people's values and identity. The surrounding sensory culture daily presents fragmented images that subtly and not-so-subtly trivialize and denigrate the dignity of the human person, create superficial desire and consumerist need, and estrange us from spiritual realities.

The Challenge of a "Culture of Images" for Evangelization and Catechesis

A 2008 national survey conducted by the Pew Internet and American Life Project traces the widespread use and impact of video games on contemporary youth culture. (Results of these Pew surveys may be found online). The cultural phenomenon of video games, the pervasiveness of the Internet, and the contemporary "culture of images" raise challenges for the integration of Christian art in evangelization and catechesis today.

The Pew survey sampled young Americans between the ages of twelve and seventeen to understand the extent and influence of video gaming on the young. The study revealed that 97 percent of the young respondents played

video games of one kind or another. They play frequently, and their choice of games is as varied as their tastes in music or television programs. Eighty percent of those surveyed play five or more different game forms, with racing, puzzles, sports, and action games among the most popular. While this cultural reality generates both creativity and concern — even, at times, frustration — among parents, teachers, catechists, and cultural observers, it should really come as no surprise.

Another Pew survey focusing on adults and video games showed that more than half, about 53 percent, of all American adults play video games of some kind, on a computer, on cell phones, portable gaming devices, consoles, or online. Younger adults were found to be more likely than any other age group to play video games, but among older adults (age 65 and older) who play video games, nearly a third played games every day — a significantly larger percentage than all younger players, of whom about 20 percent play every day. Through this cultural phenomenon, hundreds and thousands of sensory images and sounds are part of the everyday experience of youth and adults. So how does the Church's evangelizing and catechetical mission respond to this dimension of our present cultural reality?

The Merchants of "Cool"

Movie producer Neal Moritz summed it up well in the PBS special "Merchants of Cool," when he said, "Teenagers have a lot of disposable income. They want to go spend their money. And you know, we're more than happy to make products that they want to go spend money on." Originally aired in February 2001, the PBS program followed the

complex and billion-dollar industry of "buying and selling 'cool'" to millions of young Americans. Marketing and media industry executives from Madison Avenue, MTV, and Hollywood, whose companies target teenagers and youth, readily admitted to interviewers that the "teen market is a massive empire that they're colonizing." The world in which American teenagers and youth are growing up is a world dominated by carefully researched and aggressively marketed images that sell products, lifestyles, and values. American youth, they claim, are "the most marketed-to group of teens and young adults ever in the history of the world."

Douglass Rushkoff, the main correspondent, begins the program with these statistics:

> At 32 million strong, this is the largest generation of teenagers ever, even larger than their Baby Boomer parents. Last year teens spent more than $100 billion themselves and pushed their parents to spend another $50 billion on top of that. They have more money and more say over how they'll spend it than ever before. . . . A typical American teenager will process over 3,000 discrete advertisements in a single day, and 10 million by the time they're 18.

Rob Stone, a marketing executive interviewed on the program framed the commercial challenge posed by this generation of youth in these striking words:

> If you don't understand and recognize what they're thinking, what they're feeling, and then be able to take that in and come up with a really precise message that

you're trying to reach these kids with in their terms,
you're going to lose. You're absolutely going to lose.

The media and marketing companies speak of sending
"culture spies" into the daily world of teens, a landscape
where adults are typically unwelcome. A key strategy
includes what is called "cool hunting" — finding those teens
who exert influence and hold the respect and admiration
of their peers. Once the trendsetters, the "cool" kids, are
found, it becomes easier to "speak their language." From
the information gained, images and sounds that appeal to
youth are created, and a billion-dollar industry thrives. As
one media executive put it, whether they're reading a teen
magazine, playing a video game, or watching television
programs aimed at them, "everything is an infomercial!"

Christian Art and the Education of Children

In response to these cultural realities, the formative
power of Christian art in the education of children is
gaining attention today. Philosopher John F. Crosby
summarizes the often-neglected impact that genuine
artistic appreciation can have on the intellectual, moral
and spiritual development of children in this way:

> Sometimes Christians think of education in a way
> that takes too little account of beauty . . . Christian
> educators sometimes fail to notice the great formative
> potential that the experience of beauty has for children.
> They must not lose sight of the pedagogical wisdom of
> Plato, who has Socrates say in the *Republic* (401d-402a)
> that beautiful music has the power of entering into the
> soul of the young person and of imparting grace and

harmony to it, even as ugly music has the power of deforming the soul of the young. Plato makes it clear that it is not only musical beauty but all kinds of beauty that have this formative power . . . the experience of beauty disposes the soul of a child to "welcome reason." In fact he teaches that the beauty of which he speaks is deeply akin to the good, so that the child who is raised to respond to the beautiful is thereby sensitized to all that is good and right and worthy. The child is enabled by the experience of beauty to know good and evil by a kind of connaturality even before it receives detailed moral instruction . . . the human soul is so profoundly made for beauty that it can be deeply formed for the good by the early experience of beauty, but can also be deeply deformed by the early experience of what is ugly.[3]

To live in the world of today is to experience and to be shaped by the surrounding culture. This cultural reality is an invitation to evangelists, catechists, and those entrusted with the education of children and the spiritual formation of young adults to communicate the Gospel to people of today through the visual heritage of the Christian tradition. To effectively engage those shaped by this predominantly sensory culture, can the Church afford to dispense with sacred and religious art, music, and architecture as tools of evangelization and catechesis? In his 1999 *Letter to Artists*, Pope John Paul II offered this valuable insight:

[3] *St. Austin Review*, September/October 2006; Volume 6, No. 5.

The rediscovery of the Christian icon will help raise awareness of the urgent need to respond to the depersonalizing and often degrading effect of the multiple images that in the media condition our life . . . in a situation of increasing secularization of a society that becomes estranged from the values of the spirit, the art of the Christian tradition "gives access" to the reality of the spiritual and eschatological world.

Christian Art and the Saints — Beauty and Holiness Speak with One Voice

To conclude, the reader is offered one final rationale in support of a renewed appreciation of Christian art as a visual Gospel, one that points to the intimate connection between the saints the Church offers as models of Christian living in every age and the Christian art that has flourished in the Church's history.

The lives of the saints exemplify well the relationship of virtue and beauty; in their attested virtues, the saints hold up for us a living image of beauty in a harmonious life, graced by the Holy Spirit and perfected in divine love. It is in that sense that it has been said that the saints are like great works of art — human beings who, in openness to the Holy Spirit were purified and molded into unique icons of Christ in the world. Perhaps that is why so many people, and artists in particular, are so attracted to, so compelled by the lives of the saints. No wonder that artists through the centuries have chosen the lives of the saints for inspiration and content. Their holiness and virtue are apprehended as beautiful. And just as one delights in the cadence of a sonnet by Shakespeare, or as one in drawn

into the intense drama of light and shadow in a Caravaggio painting, the Christian stands in awe of the beauty of a saintly life purified and lived completely for God.

Moreover, in admiring the virtues of a saint's life expressed in art, the Church invites the faithful to imitation in a life of similar virtues. John Saward reflects on the beauty of the lives of the saints as founded upon the virtuous life with this insight:

> The virtues shine dazzlingly, heroically in the lives of the saints . . . there is beauty in the natural moral virtues, those a man acquires by his own unaided efforts, but there is even greater beauty in the infused moral virtues, the virtues of a man who is divinized by the grace of Christ, virtues animated by the Holy Spirit's poured-in gift of charity . . . the moral virtues direct a man to their own proper object, charity takes them up to the end of ends, in the super beauty of the Trinity. The saints are lovely because they love.[4]

One striking insight from an interview given by then Joseph Cardinal Ratzinger, some two decades before his election to the papacy, sum up well the reflections of this chapter and book:

> The only really effective apologia for Christianity comes down to two arguments, namely the saints the Church has produced and the art which has grown in her womb. Better witness is borne to the Lord by

[4] *The Beauty of Holiness and the Holiness of Beauty* (San Francisco: Ignatius Press, 1997).

the splendor of holiness and art which have arisen in communities of believers . . . If the Church is to continue to transform and humanize the world, how can she dispense with beauty in her liturgies, that beauty which is so closely linked with love and with the radiance of the Resurrection? No. Christians must not be too easily satisfied. They must make their Church into a place where beauty — and hence truth — is at home.[5]

[5] *The Ratzinger Report: An Exclusive Interview on the State of the Church.* Joseph Ratzinger with Vittorio Messori (San Francisco: Ignatius Press, 1985).

IN SEARCH OF BEAUTY

The integration of works of Christian art into catechesis, evangelization, and faith formation is a challenging and rewarding task. In this brief chapter, we offer pastors, parents, teachers, catechists, and evangelists a variety of sources for Christian art and five guiding principles to discern Christian art that serves catechesis, evangelization, and faith formation.

Seeing "From Within"

During his Apostolic Visit to the United States in 2008, Pope Benedict XVI celebrated Mass at New York's St. Patrick's Cathedral. In his homily, the Pope drew attention to the beauty of that cathedral as an image of the beauty of faith itself. The cathedral, with its sacred architecture and art, reflects in stone and stained glass the rich variety of gifts within the one Body of Christ. The Holy Father's meditation on St. Patrick's Cathedral offers a fitting start to this survey of sources of Christian art and principles to guide their pastoral and practical use in faith formation, catechesis, and evangelization. For, as Pope Benedict noted:

> The first has to do with the stained glass windows, which flood the interior with mystic light. From the outside, those windows are dark, heavy, even dreary. But once one enters the church, they suddenly come

alive; reflecting the light passing through them, they reveal all their splendor. Many writers — here in America we can think of Nathaniel Hawthorne — have used the image of stained glass to illustrate the mystery of the Church herself. It is only from the inside, from the experience of faith and ecclesial life, that we see the Church as she truly is: flooded with grace, resplendent in beauty, adorned by the manifold gifts of the Spirit. It follows that we, who live the life of grace within the Church's communion, are called to draw all people into this mystery of light.[1]

The Church's mission of evangelization and catechesis is a call to "draw all people into this mystery of light," to borrow Pope Benedict's phrase. Just as stained glass is fully appreciated only from the inside of a cathedral, so, too, is the Christian faith summarized in the Creed, celebrated in the Sacraments, lived in the Christian moral life, and deepened in prayer. The preacher, catechist, teacher, or parent facilitates an encounter with the living mystery of God when their teaching invites one to live the Christian life from the "inside, from within the experience of faith and ecclesial life."

In the same way, a deeper appreciation of Christian art takes place when a person steps "inside" the life of faith and the life of the Church. For we search for, find, and appreciate the inner beauty and spiritual meaning of works of Christian art not simply as outside observers or objective bystanders. Rather, we approach it through the "eyes of faith," as pilgrims who seek to travel the path from

[1] Homily of Pope Benedict XVI, St Patrick's Cathedral, New York; Saturday, April 19, 2008.

seeing to contemplation to adoration. When masterworks of Christian art are experienced from the "inside," in Pope Benedict's words, we see the Church and, by extension, her vast heritage of Christian art as it truly is: "flooded with grace, resplendent in beauty, adorned by the manifold gifts of the Spirit."

Where do we find these treasures of sacred and religious art? And what are some basic guiding principles to interpret Christian art?

Masterpieces of Christian art, both sacred and religious, may be found in a variety of locations and sources. This brief summary is not intended as an exhaustive list of sources of Christian images, but rather as a starting point in your journey of discovering the beauty of faith in the accumulated heritage of two millennia of Christian art.

Start Locally: Parish Churches, Cathedrals, and Shrines

Your parish church is an immediate and local source for sacred and religious Christian art. Often, such works of Christian art evoke the history of the local church and the diocese, the parish patron saint or biblical figure, and the relationship of the parish to the surrounding community. Often, the art, music, and architecture in local parish churches also reflects and expresses the diversity of cultures within the community.

A parish resource such as a booklet or brochure that describes stained glass windows, mosaic, wood carvings, sculpture, musical instruments, and the diverse liturgical art and architecture of your local church can serve as an informative and creative way to initiate those of all ages

into the life and history of the community. The symbolism and meaning of these local works of Christian art will echo in the minds and hearts of those who encounter them each Sunday. As local treasures of Christian art become familiar to the faithful, they become part of the religious imagination of the community of believers.

Diocesan cathedral churches and local basilica shrines are also homes to beautiful and original works of Christian art that visually express local faith and convey church history. Catholic university chapels and religious houses, convents, and monasteries typically offer a unique collection of Christian images in paintings, stained glass, sculpture, mosaic, liturgical vessels, vestments, and sacred architecture. Organize a pilgrimage that focuses on local works of Christian art as one way to encourage appreciation for these artistic treasures. Using *lectio divina,* as outlined in this book, can also serve as a practical aid in your encounter with such local works of Christian art.

Works by contemporary Christian artists who strive to unite excellence of craftsmanship and the inspiration of faith may also be found in local churches, homes, universities, and neighborhood communities. The encouragement and support of such contemporary Christian artists is vital to a renewal of Christian art in our time.

Special Exhibits — Art Museums and Galleries

Masterpieces of Christian art are also found in modern art museums and galleries. Larger museums and galleries feature special exhibits that focus on spiritual themes, often drawing hundreds of thousands of visitors. Museums or galleries in major American cities feature prized works of

art that are often Christian in theme and origin. Typically located in the Byzantine and Renaissance collections of art museums and galleries, these masterpieces of Christian art, now valued at millions of dollars, were originally created and placed in churches, chapels, side altars, and tabernacles, as their provenance (or original location and history of ownership) reveals.

When the reader encounters, for instance, an exquisite Renaissance painting of the Madonna and Christ Child in a modern art museum, it is easy to forget that its original location and purpose was first and foremost liturgical and catechetical. But treasured masterpieces of Christian art found today in museums around the world also originally served for believers as a "pre-sacrament," in the phrase of Pope John Paul II. Now we admire and delight in the skill and artistic creativity of the master artists who created Christian art viewed in museums and galleries. Viewing these precious masterworks through the "eyes of faith" allows the viewer to experience art's capacity to lift the heart and mind through aesthetic delight to contemplate Christ's life, death, and Resurrection — the heart of every Eucharist. Once again, sacred and religious art, although removed from its original context, can continue to serve faith formation, catechesis, and evangelization. Even in our time, prized masterpieces of Christian art displayed in museums and galleries everywhere can serve as a visual Gospel when viewed through the lens of faith.

Vatican Museums

The Christian roots of western European societies are reflected in the immense treasures of Christian art that a visitor encounters there. From the largest cities to the

smallest towns and villages across Europe, the Christian faith of past centuries is undeniably and visibly expressed in works of Christian art. And, although major European cities host immense collections of Christian art in museums and art galleries, one location among many stands out as an incomparable storehouse of Christian art: the Vatican Museums, home to the world's largest collection of Christian masterpieces of art.

The vast collection of paintings, frescoes, illuminated manuscripts, tapestries, mosaic, and stained glass that make up the Vatican Museum collections may now be accessed online at www.mv.vatican.va. While one can find images of Christian art on Web sites of most museums and galleries, the Vatican Museums give the viewer unique access into the historical and spiritual riches of artistic treasures from within the Catholic tradition.

Virtual Sources of Christian Art

Today, the Internet is a ready resource for easy access to images of Christian artistic masterpieces. Numerous Web sites, accessed through popular "search engines," present high-quality images of Christian masterpieces from every artistic style and period of Christian art history. From the early Christian art of the Roman catacombs to the present day, one can find on the Internet a vast virtual catalog of masterworks of sacred and religious art. Museum Web sites that feature Christian art also provide detailed information on image rights permission and the proper use of Web images in various formats; check these Web sites for further information.

Discerning Beauty: Some General Principles for Interpreting Christian Art

The 2,000-year history of Christian art has included moments of artistic vitality, such as the Renaissance, and periods of waning, such as the twentieth century. In recent times, popular novels and movies have drawn renewed attention to the meaning and symbolism of artistic masterpieces with Christian themes. At times, classic works of Christian art have become a source of debate, controversy, and confusion, even among the faithful. For example, the fiction writer Dan Brown's interpretations of the master painting *The Last Supper* by Leonardo da Vinci, popularized in his novel and movie *The Da Vinci Code*, raised questions about contemporary interpretations of a familiar and treasured work of Christian art.

The interpretation of sacred and religious works of art is a complex task that rests on expertise and knowledge of art history, theology, and cultural and spiritual history. So what about those who seek to understand and interpret Christian art without the benefit of such specialized knowledge or scholarly research? Are there principles to guide the faithful as they seek to understand and interpret the meaning, symbolism, and history of masterworks of Christian art?

Guided by the Church's 2,000-year tradition of inspiring and supporting the creation of sacred and religious art, the reader is invited to consider the following principles for interpreting these artworks. These principles assume that a work of sacred or religious art inspired by Christian faith is rightly interpreted only when its symbolism and meaning are understood in light of the tenets of Christian faith. It makes little sense to interpret a

work of Christian art with little or no regard for the faith of Christians as that faith has been professed and lived through 2,000 years.

Once again, this brief summary of guiding principles is introductory and not meant to be exhaustive. Rather these introductory principles are offered to pastors, parents, teachers, catechists, and evangelists as they explore ways to integrate Christian art into evangelization and catechesis at home, in the parish, and in educational settings.

1. **For a genuine understanding of Christian art, choose fidelity over fads.**

 Explore the meaning of Christian art with your parishioners, students, or children within the context of the Church's tradition and life-giving faith. It makes sense to begin with the premise that a beautiful painting or sculpture expressing some aspect of Christian faith was in fact inspired by love, respect, admiration, and knowledge of that faith. Doubt, indifference, intrigue, or suspicion surrounding the artists' original intentions to faithfully express the depth and beauty of Christian faith may be fashionable for a day; the light of 2,000 years of Christian faith, teaching, and history, however, offers an alternative foundation for interpreting Christian art when compared to the shifting sands of fads and popular opinion.

2. **When in doubt about the soundness of popular theological and spiritual interpretations of Christian art, lean on the teachings and tradition of the Church.**

 When popular interpretations of sacred and religious art are at odds with Christian faith, take the opportunity to learn or relearn the fundamentals of faith. Refer to Sacred Scripture, the Creed, and the teachings of faith

as summarized in the *Catechism of the Catholic Church* and the *United States Catholic Catechism for Adults*. Such formation resources are not only authoritative and dependable; they are sources to which you can return time and time again for the theological and spiritual meanings of Christian artistic symbols, biblical events, and narratives. As summaries of Christian faith, they offer concise and comprehensive reference points to better understand and discern popular artistic interpretations.

3. **Resist "conspiracy theories" surrounding works of Christian art that contradict, deny, or disregard the basic tenets of Christian belief.**

Contemporary interpretations based on classic and familiar Christian art are less than reliable if they call into question the fundamental teachings of Christianity. Often "conspiracy theories" surrounding works of Christian art offer only "half the picture" with the market-driven intention to sell as many books as possible and garner box office success. In recent times, best-selling novelists and blockbuster movie producers have employed works of Christian art as the basis for story and movie plots that weave Christian art, intrigue surrounding historical events and persons, suspicion of religious faith, and hostility against the Catholic Church in particular and Christian faith in general. Again, *The Da Vinci Code* serves as one example among many. The common premise of such novels and movies is to take well-known and loved works of Christian art and offer interpretations that subtly (or not-so-subtly!) undermine and contradict the fundamental tenets of Christian faith. Defenders of such novels and movies will often say, "It's simply a novel, it's just fiction, it's only a movie!" But how are parents, pastors, catechists, and teachers to respond

to questions and controversies surrounding Christian art that arise from popular novels and movies?

In the first place, take care not to blithely dismiss the question, objection, or controversy as simply a product of fiction writers or movie producers. While there is no doubt that these novels and movies are works of fiction and mass entertainment, their attempts to recast Christian theological and spiritual truths for a wide audience cannot remain unchallenged. In other words, take seriously the questions posed by such controversies. Then, rather than accept the underlying assumption of doubt, suspicion, and hostility toward the Church in such popularized approaches to Christian art, take the opportunity to learn, explain, and explore the particular teachings of faith that are being called into question. Rather than simply refute erroneous ideas about Christian history, put your efforts into positively affirming the teachings of Christian faith as received through divine Revelation (through Scripture)and the Church's Tradition. For example, the divinity of Christ as the Second Person of the Blessed Trinity — a fundamental tenet of Christianity — is often subtly or overtly denied in recent popular interpretations of Christian art.

Parents, pastors, teachers, and catechists may use questions about such interpretations as "teaching moments" to lead the faithful to further reflect and understand the meaning and relevance of their baptismal faith. Read art historians, scholars, and writers whose responses offer historical and theological clarity with interpretations that harmonize with the Christian tradition and faith. Let the popular and, at times, distorted attention given to Christian faith in the mainstream media serve as an opportunity to lead others to a renewed and deeper understanding and living out of the Gospel.

4. **Question — rather than dismiss — interpretations of Christian art that require doubt and suspicion in place of faith and devotion.**

Many believers have discovered that, under the cover of historical fiction, popularized interpretations of Christian art are disrespectful of the fundamental beliefs of their faith tradition. Some cultural commentators have observed the irony of a mainstream culture that values pluralism and tolerance, while — under the guise of "entertainment" — consistently undermines, ridicules, or subverts the tenets of the Christian faith tradition.

While the historical and cultural background of a masterwork of Christian art offers unique insights, its full and true meaning and symbolism for the faithful must also be reached "from the inside," or seen with the "eyes of faith." Raising questions about the meaning of a work of Christian art should not lead one to lose one's faith. Genuine questioning leads to deeper understanding of the central mysteries of faith and the ongoing relevance of the Gospel for daily life. Remind your parishioners, students, or children to consider Christian art from within the perspective of faith rather than absorb the culturally accepted assumptions of doubt, and even hostility, toward religious faith.

Consult dictionaries and encyclopedias of Christian art as well as art history books for informative explanations on the origins of a work of Christian art, the artist who created it, the symbols and artistic attributes, and the historical and cultural settings in which it was originally created. Learning to "read" a work of art takes time and effort. Today, such research is more easily accomplished through the Internet and other virtual learning tools (although accuracy of online

sources should always be verified). Taking time to learn more about the history and symbolism of an artistic masterpiece is not only helpful for a sound interpretation of a work of Christian art but may be incorporated into preaching, teaching, catechesis, and evangelization.

5. **Become an aficionado of Christian art.**

 Rather than leave it to the sphere of scholars, art experts, and connoisseurs, take it upon yourself to let Christian art become a personal interest and passion. Look for opportunities to deepen your understanding of Christian art history, such as enrolling in courses or attending lectures on art offered locally. Even a basic knowledge of Christian art history helps the faithful to discern between interpretations of a work of Christian art that are commercially driven and subversive and those that are respectful and faithful to Christian faith and tradition. Given the vast heritage of sacred and religious art in paintings, sculpture, stained glass, sacred music, and sacred architecture, chances are your journey of discovery will not be exhausted quickly or easily. As you deepen your knowledge and understanding of Christian art, the words of St. Paul will increasingly become a personal reality:

 Whatever is honorable, whatever is just, whatever is pure, whatever is lovely, whatever is gracious, if there is any excellence, if there is anything worthy of praise, think about these things.

 — Phil 4:8

APPENDIX

LETTER OF HIS HOLINESS POPE JOHN PAUL II TO ARTISTS, 1999

To all who are passionately dedicated
to the search for new "epiphanies" of beauty
so that through their creative work as artists
they may offer these as gifts to the world.

"God saw all that he had made, and it was very good"
(Gen 1:31).

The artist, image of God the Creator

1. None can sense more deeply than you artists, ingenious creators of beauty that you are, something of the pathos with which God at the dawn of creation looked upon the work of his hands. A glimmer of that feeling has shone so often in your eyes when — like the artists of every age — captivated by the hidden power of sounds and words, colours and shapes, you have admired the work of your inspiration, sensing in it some echo of the mystery of creation with which God, the sole creator of all things, has wished in some way to associate you.

 That is why it seems to me that there are no better words than the text of Genesis with which to begin my Letter to you, to whom I feel closely linked by experiences reaching far back in time and which have indelibly marked my life. In writing this Letter, I intend to follow the path of the fruitful dialogue between the Church and artists which has gone on unbroken through two thousand years of history, and which still, at the threshold of the Third Millennium, offers rich promise for the future.

 In fact, this dialogue is not dictated merely by historical accident or practical need, but is rooted in the very essence of both religious experience and artistic creativity. The opening page of the Bible presents God as a kind of exemplar of everyone who produces a work: the human craftsman mirrors the image of God as Creator. This relationship is particularly clear in the Polish language because of the lexical link between the words *stwórca* (creator) and *twórca* (craftsman).

 What is the difference between "creator" and "craftsman"? The one who creates bestows being itself, he brings something out of nothing — *ex nihilo sui et*

subiecti, as the Latin puts it — and this, in the strict sense, is a mode of operation which belongs to the Almighty alone. The craftsman, by contrast, uses something that already exists, to which he gives form and meaning. This is the mode of operation peculiar to man as made in the image of God. In fact, after saying that God created man and woman "in his image" (cf. Gen 1:27), the Bible adds that he entrusted to them the task of dominating the earth (cf. Gen 1:28). This was the last day of creation (cf. Gen 1:28-31). On the previous days, marking as it were the rhythm of the birth of the cosmos, Yahweh had created the universe. Finally he created the human being, the noblest fruit of his design, to whom he subjected the visible world as a vast field in which human inventiveness might assert itself.

God therefore called man into existence, committing to him the craftsman's task. Through his "artistic creativity" man appears more than ever "in the image of God", and he accomplishes this task above all in shaping the wondrous "material" of his own humanity and then exercising creative dominion over the universe which surrounds him. With loving regard, the divine Artist passes on to the human artist a spark of his own surpassing wisdom, calling him to share in his creative power. Obviously, this is a sharing which leaves intact the infinite distance between the Creator and the creature, as Cardinal Nicholas of Coosa made clear: "Creative art, which it is the soul's good fortune to entertain, is not to be identified with that essential art which is God himself, but is only a communication of it and a share in it". (1)

That is why artists, the more conscious they are of their "gift", are led all the more to see themselves and the whole of creation with eyes able to contemplate and give thanks, and to raise to God a hymn of praise. This is the

only way for them to come to a full understanding of themselves, their vocation and their mission.

The special vocation of the artist

2. Not all are called to be artists in the specific sense of the term. Yet, as Genesis has it, all men and women are entrusted with the task of crafting their own life: in a certain sense, they are to make of it a work of art, a masterpiece.

It is important to recognize the distinction, but also the connection, between these two aspects of human activity. The distinction is clear. It is one thing for human beings to be the authors of their own acts, with responsibility for their moral value; it is another to be an artist, able, that is, to respond to the demands of art and faithfully to accept art's specific dictates. (2) This is what makes the artist capable of producing objects, but it says nothing as yet of his moral character. We are speaking not of molding oneself, of forming one's own personality, but simply of actualizing one's productive capacities, giving aesthetic form to ideas conceived in the mind.

The distinction between the moral and artistic aspects is fundamental, but no less important is the connection between them. Each conditions the other in a profound way. In producing a work, artists express themselves to the point where their work becomes a unique disclosure of their own being, of what they are and of how they are what they are. And there are endless examples of this in human history. In shaping a masterpiece, the artist not only summons his work into being, but also in some way reveals his own personality by means of it. For him art offers both a new dimension

and an exceptional mode of expression for his spiritual growth. Through his works, the artist speaks to others and communicates with them. The history of art, therefore, is not only a story of works produced but also a story of men and women. Works of art speak of their authors; they enable us to know their inner life, and they reveal the original contribution which artists offer to the history of culture.

The artistic vocation in the service of beauty

3. A noted Polish poet, Cyprian Norwood, wrote that "beauty is to enthuse us for work, and work is to raise us up". (3)

The theme of beauty is decisive for a discourse on art. It was already present when I stressed God's delighted gaze upon creation. In perceiving that all he had created was good, God saw that it was beautiful as well. (4) The link between good and beautiful stirs fruitful reflection. In a certain sense, beauty is the visible form of the good, just as the good is the metaphysical condition of beauty. This was well understood by the Greeks who, by fusing the two concepts, coined a term which embraces both: *kalokagathía*, or beauty-goodness. On this point Plato writes: "The power of the Good has taken refuge in the nature of the Beautiful". (5)

It is in living and acting that man establishes his relationship with being, with the truth and with the good. The artist has a special relationship to beauty. In a very true sense it can be said that beauty is the vocation bestowed on him by the Creator in the gift of "artistic talent". And, certainly, this too is a talent which ought to be made to bear fruit, in keeping with the sense of the Gospel parable of the talents (cf. Mt 25:14-30).

Here we touch on an essential point. Those who perceive in themselves this kind of divine spark which is the artistic vocation — as poet, writer, sculptor, architect, musician, actor and so on — feel at the same time the obligation not to waste this talent but to develop it, in order to put it at the service of their neighbour and of humanity as a whole.

The artist and the common good

4. Society needs artists, just as it needs scientists, technicians, workers, professional people, witnesses of the faith, teachers, fathers and mothers, who ensure the growth of the person and the development of the community by means of that supreme art form which is "the art of education". Within the vast cultural panorama of each nation, artists have their unique place. Obedient to their inspiration in creating works both worthwhile and beautiful, they not only enrich the cultural heritage of each nation and of all humanity, but they also render an exceptional social service in favour of the common good.

The particular vocation of individual artists decides the arena in which they serve and points as well to the tasks they must assume, the hard work they must endure and the responsibility they must accept. Artists who are conscious of all this know too that they must labour without allowing themselves to be driven by the search for empty glory or the craving for cheap popularity, and still less by the calculation of some possible profit for themselves. There is therefore an ethic, even a "spirituality" of artistic service, which contributes in its way to the life and renewal of a people. It is precisely this to which Cyprian Norwid seems to allude in declaring

that "beauty is to enthuse us for work, and work is to raise us up".

Art and the mystery of the Word made flesh

5. The Law of the Old Testament explicitly forbids representation of the invisible and ineffable God by means of "graven or molten image" (Dt 27:15), because God transcends every material representation: "I am who I am" (Ex 3:14). Yet in the mystery of the Incarnation, the Son of God becomes visible in person: "When the fullness of time had come, God sent forth his Son born of woman" (Gal 4:4). God became man in Jesus Christ, who thus becomes "the central point of reference for an understanding of the enigma of human existence, the created world and God himself". (6)

This prime epiphany of "God who is Mystery" is both an encouragement and a challenge to Christians, also at the level of artistic creativity. From it has come a flowering of beauty which has drawn its sap precisely from the mystery of the Incarnation. In becoming man, the Son of God has introduced into human history all the evangelical wealth of the true and the good, and with this he has also unveiled a new dimension of beauty, of which the Gospel message is filled to the brim.

Sacred Scripture has thus become a sort of "immense vocabulary" (Paul Claudel) and "iconographic atlas" (Marc Chagall), from which both Christian culture and art have drawn. The Old Testament, read in the light of the New, has provided endless streams of inspiration. From the stories of the Creation and sin, the Flood, the cycle of the Patriarchs, the events of the Exodus to so many other episodes and characters in the history of salvation, the biblical text has fired the imagination of painters, poets,

musicians, playwrights and film-makers. A figure like Job, to take but one example, with his searing and ever relevant question of suffering, still arouses an interest which is not just philosophical but literary and artistic as well. And what should we say of the New Testament? From the Nativity to Golgotha, from the Transfiguration to the Resurrection, from the miracles to the teachings of Christ, and on to the events recounted in the Acts of the Apostles or foreseen by the Apocalypse in an eschatological key, on countless occasions the biblical word has become image, music and poetry, evoking the mystery of "the Word made flesh" in the language of art.

In the history of human culture, all of this is a rich chapter of faith and beauty. Believers above all have gained from it in their experience of prayer and Christian living. Indeed for many of them, in times when few could read or write, representations of the Bible were a concrete mode of catechesis. (7) But for everyone, believers or not, the works of art inspired by Scripture remain a reflection of the unfathomable mystery which engulfs and inhabits the world.

A fruitful alliance between the Gospel and art

6. Every genuine artistic intuition goes beyond what the senses perceive and, reaching beneath reality's surface, strives to interpret its hidden mystery. The intuition itself springs from the depths of the human soul, where the desire to give meaning to one's own life is joined by the fleeting vision of beauty and of the mysterious unity of things. All artists experience the unbridgeable gap which lies between the work of their hands, however successful it may be, and the dazzling perfection of the beauty glimpsed in the ardour of the creative moment: what they manage to express in their painting, their sculpting, their creating is no more than a glimmer of

the splendour which flared for a moment before the eyes of their spirit.

Believers find nothing strange in this: they know that they have had a momentary glimpse of the abyss of light which has its original wellspring in God. Is it in any way surprising that this leaves the spirit overwhelmed as it were, so that it can only stammer in reply? True artists above all are ready to acknowledge their limits and to make their own the words of the Apostle Paul, according to whom "God does not dwell in shrines made by human hands" so that "we ought not to think that the Deity is like gold or silver or stone, a representation by human art and imagination" (Acts 17:24, 29). If the intimate reality of things is always "beyond" the powers of human perception, how much more so is God in the depths of his unfathomable mystery!

The knowledge conferred by faith is of a different kind: it presupposes a personal encounter with God in Jesus Christ. Yet this knowledge too can be enriched by artistic intuition. An eloquent example of aesthetic contemplation sublimated in faith are, for example, the works of Fra Angelico. No less notable in this regard is the ecstatic *lauda*, which St. Francis of Assisi twice repeats in the chartula which he composed after receiving the stigmata of Christ on the mountain of La Verna: "You are beauty . . . You are beauty!" (8) St. Bonaventure comments: "In things of beauty, he contemplated the One who is supremely beautiful, and, led by the footprints he found in creatures, he followed the Beloved everywhere". (9)

A corresponding approach is found in Eastern spirituality where Christ is described as "the supremely Beautiful, possessed of a beauty above all the children of earth". (10) Macarius the Great speaks of the

transfiguring and liberating beauty of the Risen Lord in these terms: "The soul which has been fully illumined by the unspeakable beauty of the glory shining on the countenance of Christ overflows with the Holy Spirit . . . it is all eye, all light, all countenance". (11)

Every genuine art form in its own way is a path to the inmost reality of man and of the world. It is therefore a wholly valid approach to the realm of faith, which gives human experience its ultimate meaning. That is why the Gospel fullness of truth was bound from the beginning to stir the interest of artists, who by their very nature are alert to every "epiphany" of the inner beauty of things.

The origins

7. The art which Christianity encountered in its early days was the ripe fruit of the classical world, articulating its aesthetic canons and embodying its values. Not only in their way of living and thinking, but also in the field of art, faith obliged Christians to a discernment which did not allow an uncritical acceptance of this heritage. Art of Christian inspiration began therefore in a minor key, strictly tied to the need for believers to contrive Scripture-based signs to express both the mysteries of faith and a "symbolic code" by which they could distinguish and identify themselves, especially in the difficult times of persecution. Who does not recall the symbols which marked the first appearance of an art both pictorial and plastic? The fish, the loaves, the shepherd: in evoking the mystery, they became almost imperceptibly the first traces of a new art.

When the Edict of Constantine allowed Christians to declare themselves in full freedom, art became a privileged means for the expression of faith. Majestic

basilicas began to appear, and in them the architectural canons of the pagan world were reproduced and at the same time modified to meet the demands of the new form of worship. How can we fail to recall at least the old St. Peter's Basilica and the Basilica of St. John Lateran, both funded by Constantine himself? Or Constantinople's Hagia Sophia built by Justinian, with its splendours of Byzantine art?

While architecture designed the space for worship, gradually the need to contemplate the mystery and to present it explicitly to the simple people led to the early forms of painting and sculpture. There appeared as well the first elements of art in word and sound. Among the many themes treated by Augustine we find *De Musica*; and Hilary of Poitiers, Ambrose, Prudentius, Ephrem the Syrian, Gregory of Nazianzus and Paulinus of Nola, to mention but a few, promoted a Christian poetry which was often of high quality not just as theology but also as literature. Their poetic work valued forms inherited from the classical authors, but was nourished by the pure sap of the Gospel, as Paulinus of Nola put it succinctly: "Our only art is faith and our music Christ". (12) A little later, Gregory the Great compiled the Antiphonarium and thus laid the ground for the organic development of that most original sacred music which takes its name from him. Gregorian chant, with its inspired modulations, was to become down the centuries the music of the Church's faith in the liturgical celebration of the sacred mysteries. The "beautiful" was thus wedded to the "true", so that through art too souls might be lifted up from the world of the senses to the eternal.

Along this path there were troubled moments. Precisely on the issue of depicting the Christian mystery, there arose in the early centuries a bitter controversy

known to history as "the iconoclast crisis". Sacred images, which were already widely used in Christian devotion, became the object of violent contention. The Council held at Nicaea in 787, which decreed the legitimacy of images and their veneration, was a historic event not just for the faith but for culture itself. The decisive argument to which the Bishops appealed in order to settle the controversy was the mystery of the Incarnation: if the Son of God had come into the world of visible realities— his humanity building a bridge between the visible and the invisible — then, by analogy, a representation of the mystery could be used, within the logic of signs, as a sensory evocation of the mystery. The icon is venerated not for its own sake, but points beyond to the subject which it represents. (13)

The Middle Ages

8. The succeeding centuries saw a great development of Christian art. In the East, the art of the icon continued to flourish, obeying theological and aesthetic norms charged with meaning and sustained by the conviction that, in a sense, the icon is a sacrament. By analogy with what occurs in the sacraments, the icon makes present the mystery of the Incarnation in one or other of its aspects. That is why the beauty of the icon can be best appreciated in a church where in the shadows burning lamps stir infinite flickerings of light. As Pavel Florensky has written: "By the flat light of day, gold is crude, heavy, useless, but by the tremulous light of a lamp or candle it springs to life and glitters in sparks beyond counting — now here, now there, evoking the sense of other lights, not of this earth, which fill the space of heaven". (14)

In the West, artists start from the most varied viewpoints, depending also on the underlying

convictions of the cultural world of their time. The artistic heritage built up over the centuries includes a vast array of sacred works of great inspiration, which still today leave the observer full of admiration. In the first place, there are the great buildings for worship, in which the functional is always wedded to the creative impulse inspired by a sense of the beautiful and an intuition of the mystery. From here came the various styles well known in the history of art. The strength and simplicity of the Romanesque, expressed in cathedrals and abbeys, slowly evolved into the soaring splendours of the Gothic. These forms portray not only the genius of an artist but the soul of a people. In the play of light and shadow, in forms at times massive, at times delicate, structural considerations certainly come into play, but so too do the tensions peculiar to the experience of God, the mystery both "awesome" and "alluring". How is one to summarize with a few brief references to each of the many different art forms, the creative power of the centuries of the Christian Middle Ages? An entire culture, albeit with the inescapable limits of all that is human, had become imbued with the Gospel; and where theology produced the *Summa* of St. Thomas, church art moulded matter in a way which led to adoration of the mystery, and a wonderful poet like Dante Alighieri could compose "the sacred poem, to which both heaven and earth have turned their hand", (15) as he himself described the Divine Comedy.

Humanism and the Renaissance

9. The favourable cultural climate that produced the extraordinary artistic flowering of Humanism and the Renaissance also had a significant impact on the way in which the artists of the period approached the religious

theme. Naturally, their inspiration, like their style, varied greatly, at least among the best of them. But I do not intend to repeat things which you, as artists, know well. Writing from this Apostolic Palace, which is a mine of masterpieces perhaps unique in the world, I would rather give voice to the supreme artists who in this place lavished the wealth of their genius, often charged with great spiritual depth. From here can be heard the voice of Michelangelo who in the Sistine Chapel has presented the drama and mystery of the world from the Creation to the Last Judgement, giving a face to God the Father, to Christ the Judge, and to man on his arduous journey from the dawn to the consummation of history. Here speaks the delicate and profound genius of Raphael, highlighting in the array of his paintings, and especially in the "Dispute" in the Room of the Signatura, the mystery of the revelation of the Triune God, who in the Eucharist befriends man and sheds light on the questions and expectations of human intelligence. From this place, from the majestic Basilica dedicated to the Prince of the Apostles, from the Colonnade which spreads out from it like two arms open to welcome the whole human family, we still hear Bramante, Bernini, Borromini, Maderno, to name only the more important artists, all rendering visible the perception of the mystery which makes of the Church a universally hospitable community, mother and travelling companion to all men and women in their search for God.

This extraordinary complex is a remarkably powerful expression of sacred art, rising to heights of imperishable aesthetic and religious excellence. What has characterized sacred art more and more, under the impulse of Humanism and the Renaissance, and then

of successive cultural and scientific trends, is a growing interest in everything human, in the world, and in the reality of history. In itself, such a concern is not at all a danger for Christian faith, centred on the mystery of the Incarnation and therefore on God's valuing of the human being. The great artists mentioned above are a demonstration of this. Suffice it to think of the way in which Michelangelo represents the beauty of the human body in his painting and sculpture. (16)

Even in the changed climate of more recent centuries, when a part of society seems to have become indifferent to faith, religious art has continued on its way. This can be more widely appreciated if we look beyond the figurative arts to the great development of sacred music through this same period, either composed for the liturgy or simply treating religious themes. Apart from the many artists who made sacred music their chief concern — how can we forget Pier Luigi da Palestrina, Orlando di Lasso, Tomás Luis de Victoria? — it is also true that many of the great composers — from Handel to Bach, from Mozart to Schubert, from Beethoven to Berlioz, from Liszt to Verdi — have given us works of the highest inspiration in this field.

Towards a renewed dialogue

10. It is true nevertheless that, in the modern era, alongside this Christian humanism which has continued to produce important works of culture and art, another kind of humanism, marked by the absence of God and often by opposition to God, has gradually asserted itself. Such an atmosphere has sometimes led to a separation of the world of art and the world of faith, at least in the sense that many artists have a diminished interest in religious themes.

You know, however, that the Church has not ceased to nurture great appreciation for the value of art as such. Even beyond its typically religious expressions, true art has a close affinity with the world of faith, so that, even in situations where culture and the Church are far apart, art remains a kind of bridge to religious experience. In so far as it seeks the beautiful, fruit of an imagination which rises above the everyday, art is by its nature a kind of appeal to the mystery. Even when they explore the darkest depths of the soul or the most unsettling aspects of evil, artists give voice in a way to the universal desire for redemption.

It is clear, therefore, why the Church is especially concerned for the dialogue with art and is keen that in our own time there be a new alliance with artists, as called for by my revered predecessor Paul VI in his vibrant speech to artists during a special meeting he had with them in the Sistine Chapel on 7 May 1964. (17) From such cooperation the Church hopes for a renewed "epiphany" of beauty in our time and apt responses to the particular needs of the Christian community.

In the spirit of the Second Vatican Council

11. The Second Vatican Council laid the foundation for a renewed relationship between the Church and culture, with immediate implications for the world of art. This is a relationship offered in friendship, openness and dialogue. In the Pastoral Constitution *Gaudium et Spes,* the Fathers of the Council stressed "the great importance" of literature and the arts in human life: "They seek to probe the true nature of man, his problems and experiences, as he strives to know and perfect himself and the world, to discover his place in history

and the universe, to portray his miseries and joys, his needs and strengths, with a view to a better future". (18)

On this basis, at the end of the Council the Fathers addressed a greeting and an appeal to artists: "This world — they said — in which we live needs beauty in order not to sink into despair. Beauty, like truth, brings joy to the human heart and is that precious fruit which resists the erosion of time, which unites generations and enables them to be one in admiration!" (19) In this spirit of profound respect for beauty, the Constitution on the Sacred Liturgy *Sacrosanctum Concilium* recalled the historic friendliness of the Church towards art and, referring more specifically to sacred art, the "summit" of religious art, did not hesitate to consider artists as having "a noble ministry" when their works reflect in some way the infinite beauty of God and raise people's minds to him. (20) Thanks also to the help of artists "the knowledge of God can be better revealed and the preaching of the Gospel can become clearer to the human mind". (21) In this light, it comes as no surprise when Father Marie Dominique Chenu claims that the work of the historian of theology would be incomplete if he failed to give due attention to works of art, both literary and figurative, which are in their own way "not only aesthetic representations, but genuine 'sources' of theology". (22)

The Church needs art

12. In order to communicate the message entrusted to her by Christ, the Church needs art. Art must make perceptible, and as far as possible attractive, the world of the spirit, of the invisible, of God. It must therefore translate into meaningful terms that which is in itself

ineffable. Art has a unique capacity to take one or other facet of the message and translate it into colours, shapes and sounds which nourish the intuition of those who look or listen. It does so without emptying the message itself of its transcendent value and its aura of mystery.

The Church has need especially of those who can do this on the literary and figurative level, using the endless possibilities of images and their symbolic force. Christ himself made extensive use of images in his preaching, fully in keeping with his willingness to become, in the Incarnation, the icon of the unseen God.

The Church also needs musicians. How many sacred works have been composed through the centuries by people deeply imbued with the sense of the mystery! The faith of countless believers has been nourished by melodies flowing from the hearts of other believers, either introduced into the liturgy or used as an aid to dignified worship. In song, faith is experienced as vibrant joy, love, and confident expectation of the saving intervention of God.

The Church needs architects, because she needs spaces to bring the Christian people together and celebrate the mysteries of salvation. After the terrible destruction of the last World War and the growth of great cities, a new generation of architects showed themselves adept at responding to the exigencies of Christian worship, confirming that the religious theme can still inspire architectural design in our own day. Not infrequently these architects have constructed churches which are both places of prayer and true works of art.

Does art need the Church?

13. The Church therefore needs art. But can it also be said that art needs the Church? The question may seem

like a provocation. Yet, rightly understood, it is both legitimate and profound. Artists are constantly in search of the hidden meaning of things, and their torment is to succeed in expressing the world of the ineffable. How then can we fail to see what a great source of inspiration is offered by that kind of homeland of the soul that is religion? Is it not perhaps within the realm of religion that the most vital personal questions are posed, and answers both concrete and definitive are sought?

In fact, the religious theme has been among those most frequently treated by artists in every age. The Church has always appealed to their creative powers in interpreting the Gospel message and discerning its precise application in the life of the Christian community. This partnership has been a source of mutual spiritual enrichment. Ultimately, it has been a great boon for an understanding of man, of the authentic image and truth of the person. The special bond between art and Christian revelation has also become evident. This does not mean that human genius has not found inspiration in other religious contexts. It is enough to recall the art of the ancient world, especially Greek and Roman art, or the art which still flourishes in the very ancient civilizations of the East. It remains true, however, that because of its central doctrine of the Incarnation of the Word of God, Christianity offers artists a horizon especially rich in inspiration. What an impoverishment it would be for art to abandon the inexhaustible mine of the Gospel!

An appeal to artists

14. With this Letter, I turn to you, the artists of the world, to assure you of my esteem and to help consolidate a more constructive partnership between art and the

Church. Mine is an invitation to rediscover the depth
of the spiritual and religious dimension which has been
typical of art in its noblest forms in every age. It is with
this in mind that I appeal to you, artists of the written
and spoken word, of the theatre and music, of the plastic
arts and the most recent technologies in the field of
communication. I appeal especially to you, Christian
artists: I wish to remind each of you that, beyond
functional considerations, the close alliance that has
always existed between the Gospel and art means that
you are invited to use your creative intuition to enter
into the heart of the mystery of the Incarnate God and at
the same time into the mystery of man.

Human beings, in a certain sense, are unknown to
themselves. Jesus Christ not only reveals God, but "fully
reveals man to man". (23) In Christ, God has reconciled
the world to himself. All believers are called to bear
witness to this; but it is up to you, men and women who
have given your lives to art, to declare with all the wealth
of your ingenuity that in Christ the world is redeemed:
the human person is redeemed, the human body is
redeemed, and the whole creation which, according to St.
Paul, "awaits impatiently the revelation of the children of
God" (Rom 8:19), is redeemed. The creation awaits the
revelation of the children of God also through art and in
art. This is your task. Humanity in every age, and even
today, looks to works of art to shed light upon its path
and its destiny.

The Creator Spirit and artistic inspiration

15. Often in the Church there resounds the invocation to
the Holy Spirit: Veni, Creator Spiritus . . . — "Come, O

Creator Spirit, visit our minds, fill with your grace the hearts you have created". (24)

The Holy Spirit, "the Breath" (ruah), is the One referred to already in the Book of Genesis: "The earth was without form and void, and darkness was on the face of the deep; and the Spirit of God was moving over the face of the waters" (1:2). What affinity between the words "breath - breathing" and "inspiration"! The Spirit is the mysterious Artist of the universe. Looking to the Third Millennium, I would hope that all artists might receive in abundance the gift of that creative inspiration which is the starting-point of every true work of art.

Dear artists, you well know that there are many impulses which, either from within or from without, can inspire your talent. Every genuine inspiration, however, contains some tremor of that "breath" with which the Creator Spirit suffused the work of creation from the very beginning. Overseeing the mysterious laws governing the universe, the divine breath of the Creator Spirit reaches out to human genius and stirs its creative power. He touches it with a kind of inner illumination which brings together the sense of the good and the beautiful, and he awakens energies of mind and heart which enable it to conceive an idea and give it form in a work of art. It is right then to speak, even if only analogically, of "moments of grace", because the human being is able to experience in some way the Absolute who is utterly beyond.

The "Beauty" that saves

16. On the threshold of the Third Millennium, my hope for all of you who are artists is that you will have an

especially intense experience of creative inspiration. May the beauty which you pass on to generations still to come be such that it will stir them to wonder! Faced with the sacredness of life and of the human person, and before the marvels of the universe, wonder is the only appropriate attitude.

From this wonder there can come that enthusiasm of which Norwid spoke in the poem to which I referred earlier. People of today and tomorrow need this enthusiasm if they are to meet and master the crucial challenges which stand before us. Thanks to this enthusiasm, humanity, every time it loses its way, will be able to lift itself up and set out again on the right path. In this sense it has been said with profound insight that "beauty will save the world". (25)

Beauty is a key to the mystery and a call to transcendence. It is an invitation to savour life and to dream of the future. That is why the beauty of created things can never fully satisfy. It stirs that hidden nostalgia for God which a lover of beauty like St. Augustine could express in incomparable terms: "Late have I loved you, beauty so old and so new: late have I loved you!". (26)

Artists of the world, may your many different paths all lead to that infinite Ocean of beauty where wonder becomes awe, exhilaration, unspeakable joy.

May you be guided and inspired by the mystery of the Risen Christ, whom the Church in these days contemplates with joy.

May the Blessed Virgin Mary be with you always: she is the *"tota pulchra"* portrayed by countless artists, whom Dante contemplates among the splendours of Paradise as "beauty that was joy in the eyes of all the other saints". (27)

"From chaos there rises the world of the spirit". These words of Adam Mickiewicz, written at a time of great hardship for his Polish homeland, (28) prompt my hope for you: may your art help to affirm that true beauty which, as a glimmer of the Spirit of God, will transfigure matter, opening the human soul to the sense of the eternal.

With my heartfelt good wishes!

— From the Vatican, 4 April 1999, Easter Sunday

[1] Dialogus de Ludo Globi, lib. II: Philosophisch-Theologische Schriften, Vienna 1967, III, p. 332.

[2] The moral virtues, and among them prudence in particular, allow the subject to act in harmony with the criterion of moral good and evil: according to *recta ratio agibilium* (the right criterion of action). Art, however, is defined by philosophy as *recta ratio factibilium* (the right criterion of production).

[3] Promethidion, Bogumil, vv. 185-186: Pisma wybrane, Warsaw 1968, vol. 2, p. 216.

[4] The Greek translation of the Septuagint expresses this well in rendering the Hebrew term *t(o-)b* (good) as *kalón* (beautiful).

[5] Philebus, 65 A.

[6] JOHN PAUL II, Encyclical Letter *Fides et Ratio* (14 September 1998), 80: AAS 91 (1999), 67.

[7] This pedagogical principle was given authoritative formulation by Saint Gregory the Great in a letter of 599 to Serenus, Bishop of Marseilles: "Painting is employed in churches so that those who cannot read or write may at least read on the walls what they cannot decipher on the page", *Epistulae*, IX, 209: CCL 140A, 1714.

[8] Lodi di Dio Altissimo, vv. 7 and 10: Fonti Francescane, No. 261, Padua 1982, p. 177.

[9] Legenda Maior, IX, 1: Fonti Francesane, No. 1162, loc. cit., p. 911.

[10] Enkomia of the Orthós of the Holy and Great Saturday.

[11] Homily I, 2: PG 34, 451.

[12] "At nobis ars una fides et musica Christus": Carmen 20, 31: CCL 203, 144.

[13] Cf. JOHN PAUL II, Apostolic Letter *Duodecimum Saeculum* (4 December 1987), 8-9: AAS 80 (1988), pp. 247-249.

[14] La prospettiva rovesciata ed altri scritti, Rome 1984, p. 63.

[15] Paradiso XXV, 1-2.

[16] Cf. JOHN PAUL II, Homily at the Mass for the Conclusion of the Restoration of Michelangelo's Frescoes in the Sistine Chapel, 8 April 1994: Insegnamenti, XVII, 1 (1994), 899-904.

[17] Cf. AAS 56 (1964), 438-444.

[18] No. 62.

[19] Message to Artists, 8 December 1965: AAS 58 (1966), 13.

[20] Cf. No. 122.

[21] SECOND VATICAN ECUMENICAL COUNCIL, Pastoral Constitution *Gaudium et Spes*, 62.

[22] La teologia nel XII secolo, Milan 1992, p. 9.

[23] SECOND VATICAN ECUMENICAL COUNCIL, Pastoral Constitution on the Church in the Modern World *Gaudium et Spes*, 22.

[24] Hymn at Vespers on Pentecost.

[25] F. DOSTOYEVSKY, *The Idiot,* Part III, chap. 5.

[26] Sero te amavi! Pulchritudo tam antiqua et tam nova, sero te amavi!: Confessions, 10, 27: CCL 27, 251.

[27] Paradiso XXXI, 134-135.

[28] Oda do mlodosci, v. 69: Wybór poezji, Wroclaw 1986, vol. 1, p. 63.

The centuries-old conciliar tradition teaches us that images are also a preaching of the Gospel. Artists in every age have offered the principal facts of the mystery of salvation to the contemplation and wonder of believers by presenting them in the splendor of color and in the perfection of beauty. It is an indication of how today more than ever, in a culture of images, a sacred image can express much more than what can be said in words, and be an extremely effective and dynamic way of communicating the Gospel message.

— Cardinal Joseph Ratzinger,
Introduction to the *Compendium of the Catechism of the Catholic Church,* March 20, 2005

About the Author

Jem Sullivan, Ph.D., is an educator, speaker, and writer. Her most recent publication from Our Sunday Visitor is the *Study Guide for the U.S. Adult Catholic Catechism*.